GREAT RAILWAY JOURNEYS

London to Birmingham by Rail

ROGER MASON

AMBERLEY

First published 2013

Amberley Publishing
The Hill, Stroud
Gloucestershire, GL5 4EP

www.amberley-books.com

British Library Cataloguing in Publication Data.
A catalogue record for this book is available from the British Library.

ISBN 978 1 4456 1067 2

Typeset in 10pt on 12pt Sabon.
Typesetting and Origination by Amberley Publishing.
Printed in the UK.

Contents

Preface

A love of trains was bred into me at an early age and it has stayed with me all my life. Given a reasonable choice, I always choose to go by train rather than by car, and I do not understand why others do not feel the same. I live in Leighton Buzzard and frequently travel the route covered by this book, especially the 37 miles into Euston station in London, and while doing so I often look out of the window at the churches, monuments, grand houses and many other sites of interest that can be seen. Some are very well known, others less so, and some hardly at all. The idea for this book came to me during one of these journeys. I am interested, so it seems reasonable to suppose that others will be too.

I made the self-imposed restriction that I would only include sites that could be seen from the train. Anything over the hill or round the corner would be excluded, no matter how interesting. However, anything that could be glimpsed was fair game and qualified for inclusion. There are several sites that come into this category. Having said that, I have broken the rule to bring in two fascinating stories from the past. The first is the fight to fix the route, which I have told with Bridge HNR/200. The second is the story of the nineteenth-century railway races, which I have told in the section on Rugby.

The number and depth of the cuttings came as an unwelcome surprise. They did interfere with the view of things that I would have liked to include. Even a shallow cutting has a significant effect. At the beginning I resolved to visit each of the forty sites and take all of the photographs. I did indeed visit every site, plus some that were not suitable for inclusion, and I took all but one of the photographs. The sole exception was Bradwell Abbey, which was temporarily covered in protective sheeting.

This is my eighteenth book and I have enjoyed writing it more than any of the others. I very much hope that you enjoy reading it.

Roger Mason

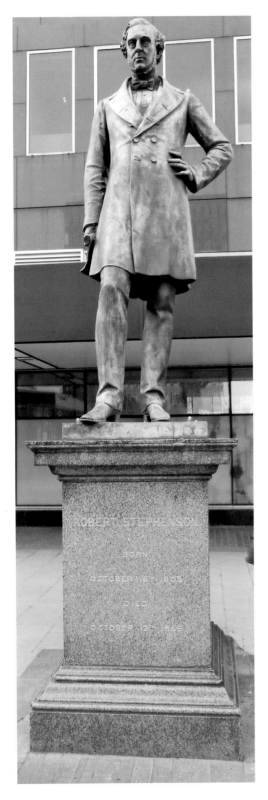

Robert Stephenson's statue at
Euston Station.

Euston Station

Euston is one of three major stations within a short distance on the north side of Euston Road. The others are St Pancras and King's Cross. It is the London terminus of the West Coast Main Line and a gateway to the Midlands, the North West and Scotland. It is the sixth busiest of the London stations and has eighteen platforms, including two that are extra long to accommodate the sixteen-carriage Caledonian Sleeper services.

The station was named after the Dukes of Grafton and Earls of Euston, who between them owned much of the surrounding land. It opened on 20 July 1837 and was the London terminus of the London & Birmingham Railway. The station was designed by the eminent Philip Hardwick, constructed by William Cubitt and had the distinction of being London's first intercity station.

To start with there were only two platforms. The gradient out of Euston is 1 in 70, which was too steep for the locomotives of the time, so until 1844 carriages were hauled up the bank to Camden by cables beneath the tracks. These were powered by two stationary steam engines. Locomotives were coupled to the trains at Camden and took the trains away.

The station expanded considerably as the traffic grew and it became an admired piece of railway architecture; perhaps even the word 'loved' would not be out of place. There was a notable wrought-iron roof and the spectacular Great Hall was opened in 1849. This was designed by Philip Hardwick's son Philip Charles Hardwick. It was 126 feet long, 61 feet wide and 64 feet high, and had an imposing double flight of stairs leading to the offices at the northern end of the hall. Its features included eight allegorical statues by John Thomas, each one representing a city served by the line.

The jewel in the crown was the Euston Arch, a 72-foot-high Doric propylaeum designed by the renowned railway architect Philip Hardwick. You will be in good company if you are not sure what a propylaeum is; I had to refer to the dictionary to confirm that it is 'a portico, especially one that forms the entrance to a temple'. Euston station in the 1840s and subsequently was a veritable temple. The arch was the largest propylaeum ever built. It was supported on four columns and four piers, and built with stone from Bramley Fall in Yorkshire.

It would be extremely difficult to find anyone who loves or even admires the present station, which was opened in 1968, with a second phase completed in the late 1970s. In fact, words like bleak, brutal and monstrous are often used, though I confess to being in a minority that think that it is just about OK. As with so many things, the damage was done in the 1960s. In 1960 the British Transport Authority gave notice of its intention to demolish Euston Station in its entirety, including the Grade II listed Great Hall and the Grade II listed Euston Arch. This was part of the plan to electrify the West Coast Main Line.

The proposals provoked much discontent and above all horror at the completely unnecessary plan to demolish the Euston Arch. John Betjeman and many others campaigned vigorously to have it left where it was or moved a short distance to another part of the site. If all else failed, they wanted it preserved and re-erected at a different location. All their efforts failed and the Minister of Transport, Ernest Marples, gave the go-ahead for the demolition. Readers of a certain age may remember the slogan 'Marples must go' in the years leading up to the 1964 general election, though this had little if anything to do with the Euston Arch.

More than half of the stone from the arch is buried in the bed of the Prescott Channel, which, via a subsidiary river, feeds into the River Lea in east London. There are thoughts about recovering the stone and rebuilding the Arch, but I suspect that it is a rather fanciful idea and will never happen. However, the ornamental gates from the Arch were saved and are kept at the National Railway Museum in York.

The station is set some way back from Euston Road. It is fronted by a concourse that leads to a small but pleasant grassy area with trees. Unfortunately, litter is sometimes noticeable in these two places, but this is perhaps inevitable with so many people using them. It is a shame though.

You can still see the pair of lodges that flanked the Euston Arch, and you may notice that their walls list a number of towns and cities that were served by the railway. Before entering the station you may care to pause at the imposing Grade II listed war memorial. The obelisk is made of Portland stone. A panel reads,

In grateful memory of 3,719 men of the London and North Western Railway Company who for their country, justice and freedom served and died in the Great War 1914–1919. This monument was raised by their comrades and the company as a lasting memorial to their devotion.

The memorial was unveiled by Earl Haig in 1921 and reference to the dead of the Second World War was added later. You will see a number of poppy wreaths at the base 365 days a year. They are always there because, in the revered words said on Armistice Day, 'we will remember them'.

You may be interested in a sculpture and a statue. The sculpture is located on the right-hand side looking out from the station, just into the grassy area. It is named *Piscator* and is by Sir Eduardo Paolizzi, who despite his name was a Scottish sculptor and artist. The sculpture was dedicated to the German theatre director Erwin Piscator, from whom it takes its name. It was commissioned by the British Railways Board and a number of businesses, and was presented to the nation through the Arts Council of Great Britain in 1981. It is a solid, horizontal structure and to my untutored eye rather curious, but I am not the right person to make a constructive comment.

The statue depicts the great railway engineer Robert Stephenson. It needs no interpretation and the plate on it assumes that the reader will know of the man and what he did. It simply reads 'Robert Stephenson, Born October 16th 1803, Died October 12th 1859'.

The statue was originally in the old ticket hall but was moved to its present position when this was demolished. It is now located on the concourse outside the station, on the right-hand side facing out.

Robert Stephenson was the chief engineer of the London & Birmingham Railway and responsible for the construction of the line. He was only twenty-nine when he was given the job in 1833 and thirty-four when it was completed in 1838. It would take a lot longer to complete a similar project now but, to be fair, much of the extra time would be spent arguing about it. Stephenson had to argue too and he had to make significant changes to his preferred route, but he would probably have gone to his grave before finishing the HS2 high-speed railway, the construction of which is expected to be protracted.

Robert Stephenson was the son of the famous railway and locomotive engineer George Stephenson and they worked together on many projects. He started young, and at the age of just twenty-one he built railway locomotives and managed his own company in Newcastle, Robert Stephenson & Company, which he founded with his father and Edward Pease. Robert built 'Stephenson's *Rocket*', which won the Rainhill Trials in 1829 and was perhaps the most famous railway engine ever built.

The impressive achievements of Robert Stephenson continued after his work on the London & Birmingham Railway. He was associated with many railway projects, both in Britain and overseas, and is remembered for a number of superlative bridges. He became Conservative MP for Whitby in 1847 and held this position until his relatively early death. He died less than a month after his friend Isambard Brunel and he was buried in Westminster Abbey next to Thomas Telford.

Euston is the intended terminus of the new high-speed train route to Birmingham (HS2). This is very controversial but there is now a commitment to build it, though a change of mind cannot be entirely ruled out. Providing that it does go ahead, there will be great changes at Euston in a few years' time. It is planned that the station will be extended to twenty-four platforms and that the high-speed line will run all the way in. There may be some limited improvements to the existing station in advance of the HS2 works. There will obviously be some disruption while the work is done.

Regent's Canal and Pirate Castle

The line crosses the Regent's Canal about 2½ minutes after leaving Euston. The Pirate Castle juts out into the canal and may be seen on the right-hand side of the train.

Regent's Canal was named after the Prince Regent (later George IV) and opened in 1820. It is 8½ miles long and links the Paddington Arm of the Grand Union Canal with the River Thames at Limehouse. During the nineteenth century there were abandoned plans to convert the canal into a railway. This would have made it a sort of partial railway equivalent of the M25 linking the main lines coming out of north London, and the spot from which you look at the canal would have been a railway junction.

The canal forms an arc through the inner part of north and east London. There are several tunnels, including the 969-yard Islington Tunnel, and it makes an interesting

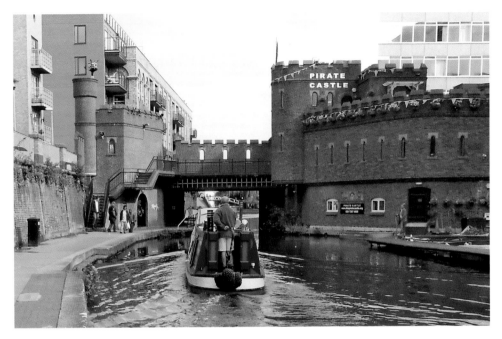

Regent's Canal and Pirate Castle.

and in places surprisingly pretty walk. It starts at what has become known as 'Little Venice' and passes through the northern part of Regent's Park, bisecting London Zoo along the way.

The Pirate Castle easily catches the eye and looks intriguing. You might think that it is a children's play centre or a public house, but that is not the case. It is Camden's canal-side community centre and boating club, run by a small staff supported by volunteers. It is a registered charity that provides affordable activities both on and off the water and, in their words, a place for the community to come together. When I visited it was a hive of activity, and I quickly formed the impression that it is run by very nice people and that it is a 'good thing'.

The Pirate Castle caters for all ages and types. You could say, in the words of the Book of Common Prayer, that it is for 'all sorts and conditions of men', though I should add women and children, including the disadvantaged and disabled. The main activity is canoeing and kayaking, but there are a lot of other things going on. These include trips on two canal narrowboats, one of which is wide-beamed with disabled access. The Pirate Castle's website is www.thepiratecastle.org.

Camden Lock (also known as Hampstead Road Locks) is just a short distance beyond the Pirate Castle. It is a very attractive double lock with an equally attractive footbridge. Hawley Lock and Kentish Town Lock are not far away. There is a lot going on, including boat trips, one of which is billed as a floating restaurant. Numerous eating stalls and other stalls merge almost seamlessly into Camden Markets. This is an exciting collection of what seems like hundreds of stalls. Words to describe them would include quirky, modern and way-out. Unsuitable words would include upmarket and

traditional. The stalls feature a vast array of such things as posters, cards, clothes, shoes, bags and music.

Camden Lock and Camden Markets are well worth a visit. They are located a couple of minutes' walk from Camden Town underground station, which is on the Northern Line. The Pirate Castle is on Oval Road nearby.

The Roundhouse

The Roundhouse will be reached about 3 minutes after leaving Euston. It is on the right-hand side of the train, just beyond a Morrisons superstore and about 300 yards past the Regent's Canal. It can only be seen for a short distance, but it should be easy to identify because, as its name suggests, it is round.

The Grade II listed Roundhouse is a building that tends to inspire affection – perhaps due to its pleasing round shape and conical roof, or its history and exciting current activities. The Roundhouse has come a long way and fulfilled many purposes. It was built as an engine shed in 1847 and contained a turntable, which accounts for its distinctive shape. However, it was only occupied in this way for a decade and was only used for railway purposes until 1869. In that year it was sold, and the building was then used as a warehouse until shortly before the Second World War. For fifty of those years, starting in 1871, it was a bonded store for the gin distillers W. & A. Gilbey Ltd.

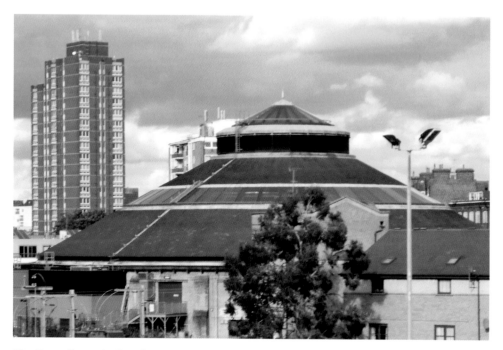

The Roundhouse in Camden.

The building fell into disuse in the late 1930s and was unoccupied until the playwright Arnold Wesker came to its rescue in 1964. He established the Centre 42 Theatre Company, with ambitious plans for the building. Many of these came to fruition, but due to lack of funds the Roundhouse eventually closed again, this time for thirteen years.

From then on it was all good news. The building was purchased by the Norman Trust in 1996 and the Roundhouse Trust was established in 1998: performing arts had returned. A £30 million redevelopment started in 2004, and the Roundhouse opened in its current manifestation in 2006.

Judging by the programme at the time of my visit there is a lot going on. Activities are in a wide range of performing arts including music, theatre, dance, circus and digital media. The Roundhouse is a registered charity and alongside its role as an arts venue there is a creative programme for people aged eleven to twenty-five through the Roundhouse Trust, which aims to engage young people in music, media and the performing arts. It includes twenty-four studios. Since its reopening in 2006 more than 650,000 people have been through the doors and over 12,000 young people have developed their creative talents.

The Roundhouse website is www.roundhouse.org.uk. The building is on Haverstock Hill and it is 100 yards from Chalk Farm underground station.

Wembley Stadium

The arch above Wembley Stadium is 440 feet high and I have seen it very clearly from Legoland in Windsor, so you should not have any problems locating this one. It is about a quarter of a mile from the track on the right-hand side of the train, just before Wembley Central station. It can be seen during the preceding mile or so.

The last match at the old Wembley Stadium was played on 7 October 2000. A disappointing England team lost 0-1 to Germany, and a despondent Kevin Keegan resigned in the dressing room 5 minutes after the final whistle. The plan was to demolish the old stadium by the end of the year and to open the new Wembley Stadium in 2003, but an awful lot went wrong. As the project progressed, time and cost overruns became embarrassing. Originally budgeted at £326 million, the stadium finally came in at a staggering £797 million, and it was finally handed over on 9 March 2007, in time to host the 2007 FA cup final.

When it was opened, most people were pleased with what they had eventually got. There is so much inside the complex that it is a kilometre around the perimeter. The seating capacity is 90,000 and it has a partially retractable roof. Of course there is the famous Wembley Arch with a span of 1,040 feet, which makes it the longest single-span structure in the world. The stadium is said to be the most technically advanced in the world, though there are no doubt some who would dispute the claim. The facilities inside are breathtaking. You should have a brilliant view and (at a price) be very well looked after. The cost can be very considerable. A twenty-seat box on the halfway line

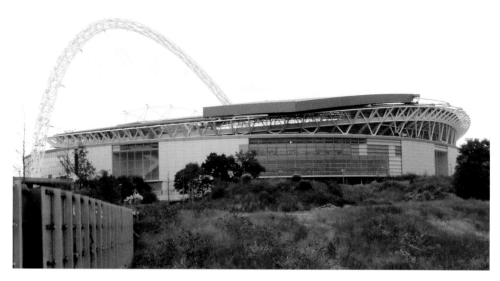

Wembley Stadium.

for ten years costs £2.4 million. This covers all events at the stadium, but not food and drink.

It is interesting to record some of the differences with the old stadium that it replaced. All 90,000 spectators of course sit in roomy, individual seats, whereas in the old stadium they sat on long uncomfortable benches. There are no pillars, whereas the old stadium had seventeen of them. Perhaps the most notable difference of all is that there are 2,816 toilets compared with just 380 in the old Wembley. Writing as a man who has watched a Wembley match with a restricted view while working out how to get to a toilet, it is a big improvement.

As you would expect, football is the main activity. Each year Wembley hosts the FA Cup final and semi-finals, the League play-offs, the FA Community Shield, the final of the Football League Cup and all of England's home international matches. There has also been the final of the Champions League and the football finals of the London Olympics. Apart from football there are major Rugby League games, one match each season from the American National Football League's International Series, and sometimes large concerts are held there.

The new Wembley Stadium inherited a mountain of nostalgic memories from the old one that it replaced, and it has much to do to build on its inheritance. The old stadium, famous for its twin towers, was built for the British Empire Exhibition of 1924, and incredibly it was originally intended that it be demolished in 1925. The first event held there was the 1923 FA Cup final, which was not an all-ticket game. The official capacity of the ground was 127,000, but something like double that number crammed inside, with a further 60,000 stranded outside. Photographs show that they were nearly all men and that almost all of them were wearing hats. The scope for a catastrophe

was terrifying, but the afternoon passed without incident. Bolton Wanderers beat West Ham 2-0. David Jack scored in every round and got both goals in the final.

The old stadium hosted numerous England internationals, five European Cup finals, the final of Euro '96 and the annual FA Cup finals, including the celebrated one in 1953 when Stanley Matthews put on a dazzling display and Stanley Mortensen scored a hat-trick to win the cup for Blackpool. Other sports using Wembley were Rugby League, speedway and greyhound racing. These last two sports were very popular and regularly attracted enormous crowds.

The 1948 Summer Olympics were held at Wembley. These were the friendly, austerity games and were held at a time of rationing. Some of the British competitors made their own kit and some took their annual leave from work in order to compete. The highlight of the games was a stunning performance by the Dutch housewife Fanny Blankers-Koen. The pregnant thirty-year-old mother of two won four gold medals. She might have won two more if she had not been restricted to competing in just four events.

Perhaps the most memorable event of all was the 1966 World Cup final when England beat West Germany 4-2. The citizens of East London call it the day that West Ham won the World Cup. The team provided the inspirational captain (Bobby Moore), the man who scored a hat-trick (Geoff Hurst), and the man who scored the other goal and was described by Alf Ramsey as a player ten years ahead of his time (Martin Peters). It was the match that produced the most memorable quote in football commentary. As the final seconds ticked away and Geoff Hurst scored his third goal, Kenneth Wolstenholme said, 'Some people are on the pitch. They think it's all over. It is now.'

Apart from sport, in 1975 the American stuntman Evel Knievel jumped a motor bike over thirteen double-decker buses in front of a crowd of 90,000. He crash-landed, breaking his pelvis, vertebrae and hand. In 1985 Prince Charles and Princess Diana opened the Live Aid concert, which Bob Geldof inspired and did so much to promote. It was widely reported, not always favourably, that Prince Charles seemed to be the only man in the stadium wearing a tie. As an inveterate tie man I think that His Royal Highness got it right.

I can thoroughly recommend the 75-minute Wembley Tour. Booking details are on the website: www.wembleystadium.com. My review of Wembley Stadium has been favourable, which was not what I expected. I had not previously visited the new stadium and I approached it in a negative frame of mind, caused partly by the delays and the massive cost of building it. However, I was won over; Wembley Stadium is magnificent.

Harrow School

Harrow School is at Harrow on the Hill, which is on the left-hand side of the train and about 1½ miles from the track. From Wembley Central there are three intervening

underground stations before Harrow & Wealdstone station. They are North Wembley, South Kenton and Kenton. Harrow on the Hill can be seen for part of the way between South Kenton and Kenton. It cannot be seen from Harrow & Wealdstone station.

Looking across some playing fields you will see two spires on a hill. The higher one on the right is the parish and borough church of St Mary, Harrow on the Hill. The lower one on the left, which is green, is the chapel of Harrow School. Harrow is one of Britain's most famous public schools and is often grouped with Eton in the public consciousness. It was founded in 1572 under a Royal Charter granted by Queen Elizabeth I. Divided into twelve houses, it has 830 pupils, all boys and all boarders. At the time of writing its fees are £10,720 per term or £32,160 per academic year.

The school is at the top of a hill, with 400 acres and, remarkably, its own farm. Buildings facing the road include the chapel, which can be seen from the train. It is a large, impressive building with stained-glass windows. Another impressive building is the Vaughan Library. A plaque states, 'The first stone of the Vaughan Library was laid by Viscount Palmerston KG, Lord of Her Majesty's Treasury, Thursday July 4 1861.' His stated title is interesting. The Prime Minister's official title is First Lord of the Treasury, though it is not often used.

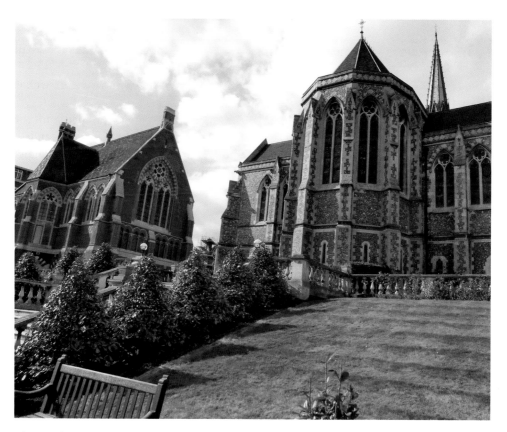

The Vaughan Library and the chapel at Harrow School.

Many of the world's major sports were invented, developed or codified in Britain. The public schools played a leading part and Harrow was no exception. The game of rackets was developed into squash at Harrow in 1830, and now it is of course an international sport. The school was one of seven that met in 1863 to develop rules for football. These influenced the Football Association's first set of rules, published later in the same year. The annual Eton *v.* Harrow cricket match was first played in 1805 and is one of the longest-running cricket fixtures in the world. It is played at Lord's and was once one of the highlights of 'the season', attracting large crowds – 38,000 over two days in 1914 for example. Excluding the two world wars, there have been 174 games in the series. Eton has won more, but Harrow has dominated in recent years.

As you might expect, the list of distinguished former pupils is long and it is only possible to mention a very few. They include Jawaharlal Nehru, the first Prime Minister of India; King Hussein of Jordan; the social reformer Lord Shaftesbury and actor Benedict Cumberbatch. Writers include Lord Byron, John Galsworthy, Sir John Mortimer, G. M. Trevelyan and Anthony Trollope. Randall Thomas Davidson was a much respected Archbishop of Canterbury for twenty-five years from 1903. Britain's armed forces have benefited from the services of Field Marshall Lord Gort, Field Marshall Alexander and the 7th Earl of Cardigan, who led the Charge of the Light Brigade at Balaclava. The school has educated twenty recipients of the Victoria Cross and one recipient of the George Cross.

Britain has had fifty-three Prime Ministers since Sir Robert Walpole took office in 1721. Harrow has provided seven of them: Spencer Perceval, 1809–12; Frederick John Robinson, Viscount Goderich, 1827/28; Sir Robert Peel, 2nd Baronet, 1834/35 and 1841–46; George Hamilton Gordon, 4th Earl of Aberdeen, 1852–55; Henry John Temple, 3rd Viscount Palmerston, 1855–58 and 1859–65; Stanley Baldwin 1923/24, 1924–29 and 1935–37; and Sir Winston Leonard Spencer Churchill 1940–45 and 1951–55.

I must include something about Churchill, but this is not a book about Prime Ministers and so there is only room to further mention just three of the others, starting with Spencer Perceval, who is unique for a special and very sad reason. He was assassinated in the lobby of the House of Commons, the only Prime Minister to die in this way. Justice was swift in those days. Despite a plea of insanity by his counsel, the assassin was tried, convicted and executed within seven days.

Viscount Palmerston became a minister at the age of twenty-three and held government office almost continuously for fifty-seven years. Excepting a short break, he was Prime Minister for the last ten years of his life and died in office two days short of his eighty-first birthday. He was probably the most English of Prime Ministers, as is evidenced by a remark made to a Frenchman: 'If I were not a Frenchman, I should wish to be an Englishman,' said the Frenchman. 'If I were not an Englishman, I should wish to be an Englishman,' Palmerston replied.

On 24 June 1919 *The Times* published a letter signed FST. It said that the writer was going to give a fifth of his fortune to the nation, in a bid to help repay its First World War debt. Four years later it became known that FST meant Financial Secretary to the Treasury, who at the time was Stanley Baldwin. The amount given was £120,000, but, despite his hopes, very few people followed his example.

Roy Jenkins wrote acclaimed biographies of Sir Winston Churchill and William Gladstone, and he expressed the view that Churchill was just ahead of Gladstone as Britain's greatest Prime Minister. Who am I to disagree? Sir Winston led Britain in the Second World War and again in the 1950s. He was a leading politician for more than fifty years, a journalist, war correspondent and painter. As a soldier he took part in the British army's last cavalry charge at Omdurman, and he wrote brilliant books and won the Nobel Prize for Literature.

He did not do very well at Harrow, though not as badly as is sometimes supposed. He did, though, benefit enormously from the tuition of Robert Somerville, the lower school English master, and he later paid tribute to him. Throughout his life Churchill had a prodigious memory. While in the lower school he won a prize by reciting from memory a 1,200-line Macaulay poem.

Thousands of stories can be told to show the humanity of the man. Here is just one. During the war Churchill invited a very young airman who had just been awarded the Victoria Cross to meet him in Downing Street. The young man was overcome with nerves and was unable to speak. Churchill said, 'When you are in the presence of a very great man it is very difficult to find words.' The young man could only nod. 'I'm glad that you know that,' said Churchill, 'because you will understand just why I am finding it so difficult to say anything at this moment.'

This has developed into a roll call of the great and the good, so perhaps the name of a Harrow pupil hanged for treason should be introduced. This was John Amery, born in 1912 and the son of Leo Amery, a cabinet minister who was also educated at Harrow. John Amery was a troubled boy who left the school after a year. During the war he broadcast from Nazi Germany and tried to recruit British prisoners of war to fight for Germany on the eastern front. After the war he pleaded guilty to charges of treason and was sentenced to death. The hangman, Abert Pierrepoint, wrote, 'He was the bravest man I ever hanged.' One report has it that Amery greeted the hangman by extending his hand and saying 'Mr Pierrepoint, I've always wanted to meet you, but not, of course, under these precise circumstances'. However, another version is that he extended his hand and just said 'Pierrepoint'.

Just before I visited Harrow School I had read Nadine Dorries' damaging remark about 'two arrogant posh boys who don't know the price of milk'. She was talking about David Cameron (Eton) and George Osborne (St Pauls), and I wondered if that would be my impression of the Harrow boys. I am pleased to say that it was not. At lunchtime 150 boys came down the road, three of them wearing the Harrow hat, often wrongly referred to as a boater, and 147 carrying it. They were smart, well-mannered, well-spoken and generally impressive. I did not ask them the price of milk, but they may well have known the answer.

The previous day, during my visit to Wembley Stadium, I had seen about 150 state school children outside Wembley Central station. In a slightly more boisterous way they too seemed smart, well-mannered, well-spoken and generally impressive. The double experience made me think that the future of our country might be in good hands. It is a pleasing prospect.

Harrow & Wealdstone Station: Scene of the 1952 Crash

Railways are an extremely safe means of travel and the chances of reaching your destination unharmed are extremely good. In fact, in many years there are no passenger fatalities at all on Britain's railways. The worst ever rail crash in England took place at Harrow & Wealdstone station at 8.19 a.m. on the foggy morning of 8 October 1952, and involved three trains. The fast line platform was occupied by the 7.31 commuter train from Tring to Euston. This consisted of nine carriages and it was carrying about 800 passengers, more than usual because the following service had been cancelled. At 8.19 it was struck in the rear by the night express from Perth. This was running 80 minutes late and consisted of eleven carriages hauled by one locomotive. It was travelling at between 50 and 60 miles per hour and was carrying about eighty-five passengers. A few seconds later a Euston to Liverpool and Manchester express travelling in the opposite direction struck the locomotive of the Perth train. This was carrying about 200 passengers and consisted of fifteen carriages hauled by two locomotives, and it was travelling at about 60 miles per hour. The leading locomotive was derailed.

Sixteen carriages were destroyed and many of them compressed and reared up very badly, which brought down the bridge over the line. The fatalities included people on the bridge and the platform as well as on the trains. In total 112 were killed, including the driver and fireman of the Perth express and the driver of the lead engine of the Liverpool express. The injured numbered 340, of which 173 were treated at the scene. 167 people were taken to hospital and 88 of these were detained at least one night.

The rescue services, needless to say, faced an appalling job. They are invariably praised after a disaster, and no doubt they almost always deserve it, but this time especially they did not let us down. The first ambulance pulled away at 8.27 and the search for survivors went on into the night. A lot of help was forthcoming. A medical unit of the United States Air Force was invaluable and saved a number of lives. The Women's Voluntary Service helped and the Salvation Army was there. As General John Gowans memorably wrote, 'there's nothing like an Army cup of tea.'

Local residents brought out sheets, blankets, cigarettes and pots of tea. A fourteen-year-old boy was on a bus on the way to Willesden Technical College. Hearing the crash, he jumped off the bus and went into the station to try and help. With the permission of firemen he used his small frame to advantage and wriggled into the wreckage to try and find survivors. He saw some awful sights but did manage to point rescuers to people who were alive. Afterwards he went to his father's office, which was nearby. His father told him that he should go home for a wash and then go to college, which he did.

In the sad and unlikely event of a comparable rail disaster happening today, it would perhaps be two weeks or more before the line was reopened. They did things differently then. The two slow lines were not damaged and these were opened at 5.32 on the following morning. The two fast lines were cleared and the track was repaired so that trains could and did use them 108 hours after the moment of impact.

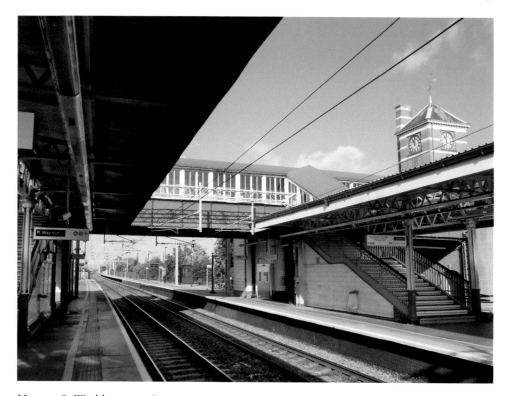

Harrow & Wealdstone station.

The driver of the Perth train did not survive to give his account of what happened, but it seems clear that error on his part was the sole cause of the crash. His train passed a caution signal and two danger signals. No fault was found with the signals or the Perth train, and the three signals were all said to be clearly visible. A post mortem on the driver showed that he had been in good health, had not drunk alcohol and had not been poisoned by carbon monoxide. It was simply a tragic case of unaccountable driver error. One consequence of the crash was to speed up the introduction of the British Rail Automatic Warning System (AWS). This warned of an adverse signal and automatically applied the brakes until it was cancelled by the driver.

I have a personal story to tell about the crash. A friend was in the front carriage of the commuter train that was hit, this of course being the least affected part of the train. Unhurt, she stepped out and returned to her home, which was close to the station, where she met her mother bringing out blankets. She had started her first job a few days before and did not want to miss going to work, so she walked to a station on another line and got to her job in central London. It was a terrible experience for her but it did have one happy consequence. She had recently split with her boyfriend, but he called in the evening to see that she was alright and to ask her to go with him to a church service that was being held because of the crash. They were very happily married for nearly fifty years.

I have passed through Harrow & Wealdstone station well over a thousand times, but until writing this book I had never visited it. Doing so was a moving experience. I stood on the platform and looked along the track in the direction from which the Perth express came, and I felt the years roll back and the ghosts walking. It was of course all in my mind, but it was eerie. My picture shows exactly what I saw. It is looking up the track towards Watford, and it shows the rebuilt footbridge.

The events of the sad day are marked with a very simple memorial placed on the outside wall just to the right of the main entrance to the station. It reads, 'In memory of the 112 people who lost their lives at Harrow and Wealdstone on October 8 1952.'

This was unveiled on 8 October 2002, the fiftieth anniversary of the crash. Another ceremony was held at 8.19 on the morning of 8 October 2012, the sixtieth anniversary. A minute's silence was observed and the names of the dead were read out. A wreath was placed with a card that read 'From the Mayor, Councillors and Burgesses of Harrow'.

Grand Union Canal

The Grand Union Canal starts in Brentford, where a lock links it to the River Thames, and it terminates in Birmingham. If Brentford is counted as London, it is the equivalent of the Euston to Birmingham railway. Ignoring the arms, the canal is 137 miles long and it contains 166 locks. In comparison, the railway is 115 miles long.

After leaving Watford Junction the railway line passes through a tunnel. The first sight of the canal is about a mile after leaving the tunnel and shortly before the train passes under the M25 motorway. The canal approaches on the left-hand side, then curves round towards Kings Langley also on the left-hand side.

This is just the first sighting of the canal and there will be many other opportunities. It runs close to the railway line all the way up to a point near Rugby. It can be seen in many places and it is never far away. Some of the views of the canal are both long and pretty.

The canal started life as the Grand Junction Canal, running from Brentford to Braunston where it linked up with the Oxford Canal. This gave it access to Birmingham and the industrial Midlands. Passage from London to Birmingham was already possible via the River Thames and the Oxford Canal, but the new canal took 60 miles off the journey and avoided periodic navigation problems in the Upper Thames.

The years 1793/94 were the high point of canal mania – in these two years there were thirty-eight Acts of Parliament for canal building. In 1793 work was in progress on sixty-two different canals. They became the waterways that fed the Industrial Revolution. The Parliamentary Bill for the Grand Junction Canal was passed in 1793, and apart from the Blisworth Tunnel it was completed in 1800. For five years until the tunnel was completed a road over the hill linked the southern and northern parts of the canal. It is worth pausing to reflect on the speed and scale of the achievement. It is 94 miles from Brentford to Braunston, and all the work was done by navvies using shovels and barrows. There were no mechanical aids. There is more about navvies when we get to Tring Cutting.

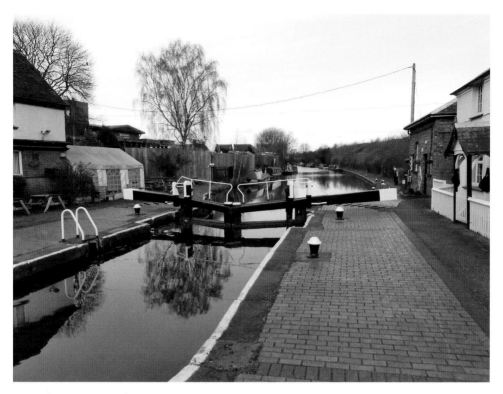

Fenny Stratford lock on the Grand Union Canal.

The Grand Junction Canal was a great commercial success, but only for a short time. The coming of the railways provided almost insurmountable opposition, and this was particularly true of Stephenson's Euston to Birmingham line which was completed in 1838. The Grand Junction responded by lowering its tariffs, but this hit profits badly and left it short of funds for investment and maintenance. In the twentieth century motor vehicles did the same thing to the railways and what was left of the canal traffic.

In 1929 the Regent's Canal Company bought the Grand Junction and also the three Warwick Canals. They became part of the new Grand Union Canal, which ran from London to Birmingham, and the name Grand Junction disappeared. The Grand Union Canal was nationalised in 1948 and control was given to the British Transport Commission. In 1962 responsibility passed to the British Waterways Board (later British Waterways).

By the early 1960s the canals were in a bad way. Freight traffic had almost finished and the increase in leisure traffic was in its infancy. They badly needed a lot of maintenance and investment. Happily the use of the canals for leisure purposes has since blossomed and they are now recognised as a valuable leisure resource. Towpaths have been restored and are widely used for walking and cycling. Fishing remains very popular. A flotilla of boats pass up and down and you will see large and busy marinas. The turnaround has been splendid.

The Ovaltine Building

The Ovaltine Building is an imposing white structure on the left-hand side of the track. It is just past Kings Langley station, which in turn is just past the point where the train passes under the M25 motorway.

The history of Ovaltine starts in Switzerland in the 1860s. The business was founded by Dr George Wander, a Swiss chemist who wanted to promote the nutritional value of barley malt. In the early 1900s his son Albert Wander formed a British company to manufacture and sell the drink Ovaltine. The first factory at Kings Langley opened in 1913 with just thirteen employees.

The business prospered throughout the 1920s and a much bigger factory was constructed on the same site. This was opened in 1929. It was designed and built by Sir Harry Hague, the head of Ovaltine, and it even contained a large ballroom. The location was ideal because it was close to the railway and close to a ready supply of labour. Furthermore, it backed onto the Grand Union Canal. The company used narrowboats (at the peak it had seven pairs) to bring in coal.

In 1930, two nearby farms were purchased. Numbers Farm at Kings Langley supplied milk and Parsonage Farm at Abbots Langley supplied eggs, both of which were key ingredients in the manufacture of Ovaltine. The farms featured prominently in advertising and promoted the wholesome, healthy image of the product.

In the 1930s Ovaltine's marketing and image were boosted by the Ovalteneys Radio Show and the Ovalteneys Club. The show commenced in 1935 and was an immediate hit. The opening song was one of the most memorable jingles of all time:

> We are the Ovalteneys,
> Little girls and boys;
> Make your requests, we'll not refuse you,
> We are just here to amuse you.
> Would you like a song or story,
> Will you share our joys?
> At games and sports we're more than keen;
> No merrier children could be seen,
> Because we all drink Ovaltine
> We're happy girls and boys.

By 1939 the Ovalteneys Club had a vast number of children as members. They had a badge, a rule book, a secret code and signals. Above all they had that memorable song. So celebrated was the song that it was popular with British troops during the war. How could Hitler possibly prevail when confronted with regiments of Ovalteneys? He had no chance.

Employment at Kings Langley peaked at just over 1,400 in the middle of the twentieth century, but although the product remained popular, a decline in numbers set in. It was down to 350 by 1990. It was decided that the farms were no longer needed, either for production or marketing purposes. In the early 1990s the buildings

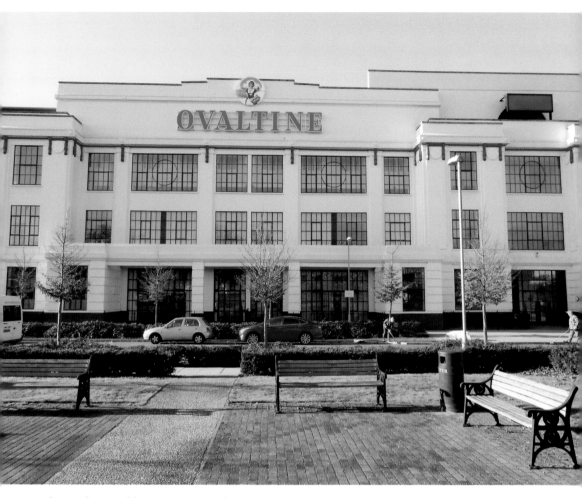

The Ovaltine Building at Kings Langley.

of Parsonage Farm were converted to residential use and a few years later the Numbers Farm buildings became the head office of a renewable energy company. A wind turbine now stands on the site of the farm. You may have seen it on the right-hand side of the track, close to the M25 Motorway and shortly before reaching the Ovaltine Building.

In 2001 Ovaltine moved operations to Switzerland. The Ovaltine Building was not listed and there were fears that it would be demolished, but happily that did not happen. It was converted into apartments. The 378-foot-long, five-storey façade has been preserved and, as you may discern from the train, it is kept in very good condition. The area behind the façade has been totally redeveloped.

The Highwayman's Grave

The highwayman's grave is marked with a white stone block less than knee height. Despite its small size it should be easily visible: it is in the middle of a field with nothing close to it, and the white colour contrasts with the surrounding green. The grave is on the left-hand side of the track, half a mile beyond Hemel Hempstead station. You should look down from an embankment, over a dual carriageway road and into a series of fields between the dual carriageway and another road.

The inscription on the gravestone simply reads 'Robert Snooks, 11 March 1802'. The name is not correct, because it actually marks the burial place of James Snooks, the last highwayman in England to be hanged at the scene of his crime. The error is believed to have occurred because the term 'Robber Snooks' was corrupted to Robert Snooks.

Snooks was born in Hungerford in 1761 and it is claimed that at one time he worked as an ostler at the Kings Arms in Berkhamsted. If this is true, his employer would have been John Page and he would have acquired some knowledge of the movement of the mail. Page was destined to later play a key role in his execution. Snooks was a petty criminal and an alleged horse thief. In the year before his final crime he had appeared at the Old Bailey accused of horse thieving, but had been acquitted.

During the late evening of 10 May 1801, Snooks held up and robbed John Stevens, who was conveying mail from Tring to Hemel Hempstead. The precise details of what was stolen are not known, but it is believed to have included banknotes with a value of at least £500. A reward of £200 was offered, this being over and above the £100 offered by Act of Parliament for anyone apprehending a highwayman or causing a highwayman to be apprehended.

Suspicion fell on Snooks because an iron-grey horse, a broken saddle and some empty mail bags were found near the scene of the crime. People recalled seeing Snooks in the vicinity with some of these items. He was apprehended because he sent a servant to buy some cloth for him. He gave her a large note from the robbery and asked her to bring him the change. There were suspicions about the size of the note and he was reported. He was by no means the first or last criminal to be caught because they spent the proceeds of their crime in a conspicuous manner.

Snooks fled to Hungerford before he could be detained. In nearby Marlborough Forest he was recognised by an old school friend who was driving by in a chaise and four. After a fight, in which the occupants of the chaise and four joined in, he was overcome. The people who apprehended him were perhaps fortunate, because his pockets were found to contain a pair of loaded pistols. He was also carrying a large sum of money.

Snooks was convicted at Hertford Assizes and then placed in the custody of the constable for the Hundred of Dacorum. This was John Page, the proprietor of the Kings Arms in Berkhamsted and possibly his previous employer. Page was instructed to arrange for Snooks to be hanged near to the place of the robbery and on public land. A local holiday was declared for 11 March 1802, the day of the execution.

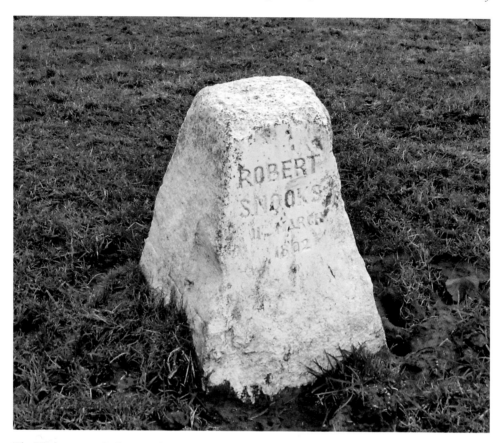

The Highwayman's Grave at Boxmoor near Hemel Hempstead.

An aspect of the story that may or may not be strictly true is that on the way to the execution Snooks was allowed a last drink at a tavern. He is supposed to have called out to the onlookers, 'It's no use hurrying – they can't start till I get there'. If this is true, he must have had remarkable fortitude and a good sense of humour.

It had been intended that Snooks would hang in chains, but this barbaric idea was abandoned following a petition by the people of Boxmoor. Instead he stood on a cart with a rope around his neck, then was left hanging from a tree as the cart was driven away. Snooks wanted his body to be taken away after his death and he offered his watch to an acquaintance if he would see that it was done. However, the acquaintance refused, not wanting to be associated with a felon.

It is reported that part of a truss of straw was laid in the grave and Snooks's body laid on it. The grave was then filled in, but shortly afterwards the local residents subscribed for a plain wooden coffin. Snooks's body was exhumed, placed in the coffin then reburied.

In 1904 the Boxmoor Trustees provided the gravestone and a footstone was added in 1994. It almost certainly does not mark the exact site of the grave, but it is in the vicinity. The exact spot could even be under the railway line.

As I researched the story, I noticed that the people of Boxmoor seemed rather decent. No doubt they still are.

Berkhamsted Castle

Berkhamsted Castle is on the right-hand side of the track immediately before Berkhamsted station. It is very close to the line and for this reason it can only be seen for about 300 yards, ending at the beginning of the station.

Berkhamsted Castle has a fascinating history, and it is one of the most interesting and important castles in England. It was once defended by a complicated arrangement of triple wet ditches with large counterscarp banks and earthwork cavaliers (high mounds of earth that can be used as look-out positions). You will see a large and peaceful area consisting of moats and earthworks together with some stone remnants. It is interesting, important and with a long and fascinating history.

Berkhamsted will always be associated with William the Conqueror. Following his victory at the Battle of Hastings on 14 October 1066 William rampaged and pillaged through southern England. Crossing the Thames at Wallingford he moved in an arc around the west of London and reached Berkhamsted. It was here that he was offered the Crown by Archbishop Aldread, the Bishops of Worcester and Hereford, Earls Eadwin and Morcar and the chief men of London. He accepted but continued pillaging his new subjects as he rode into London, where he was crowned in Westminster Abbey on Christmas Day 1066.

William ordered a number of castles to be built around London. Berkhamsted was the only double-moated Norman castle. It is mentioned in the Domesday Book and, originally a timber structure, was built for Robert Count of Mortain, who was William's half-brother.

Henry I held court at the castle in 1123. During the reigns of Henry I and Henry II it was in the hands of the chancellors and there were extensive building works at this time. The final chancellor to hold it was Thomas à Becket. In 1163 Henry believed that Thomas, who was Archbishop of Canterbury at the time, had misappropriated some money and took the castle back. It was of course Thomas à Becket who was murdered in Canterbury Cathedral by men who believed that they were acting on Henry's wishes. During his tenure, Thomas put in hand considerable works to the castle, including the construction of houses in the round keep and replacing the wooden palisades around the motte and bailey with new stone defences. It was his contention that a considerable part of the disputed money had been spent at Berkhamsted.

Subsequent to this the castle was held by a succession of monarchs, royal relatives and nobles. In 1191 Richard I (Richard the Lionheart) gave the castle to his queen, who lived there until 1199. On Richard's death it passed to his brother John, who in turn gave it to his queen who lived there until 1216. During this period John added wing walls up the south side of the motte and round towers along the bailey curtain wall. These were put to the test in 1216 when the castle was besieged by King Louis of

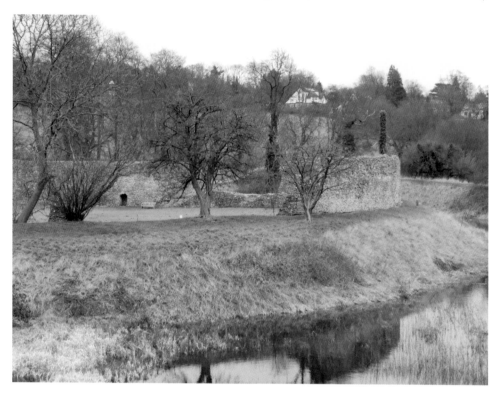

Berkhamsted Castle.

France as part of his attempt to seize the English throne. The castle fell after just two weeks due to a barrage from giant catapults called mangonels.

The castle passed through a number of hands including Richard, the younger brother of Henry III. Sadly his wife Isabel died there in 1240 following childbirth. Subsequently it was occupied by Queen Margaret and Isabella of France, Queen of Edward II, among others. In 1337 Edward III gave the castle to his son as part of the newly created Duchy of Cornwall, and it is owned by the Duchy of Cornwall to this day. In 1356 John II of France was imprisoned there after his capture by the Black Prince at the Battle of Poitiers.

To list yet more royal occupiers would perhaps be tedious, so we will move on to the last person to live at the castle, which was Cecily Duchess of York, mother of Edward IV. It has not been occupied since 1495, though it passed through the hands of three of Henry VIII's wives: Katherine of Aragon, Anne Boleyn and Jane Seymour.

Since 1495, three events have changed this valuable historic site markedly for the worse. The first and most serious can only be described as vandalism. The culprit was Sir Edward Grey, son of Mary Boleyn and therefore related to Queen Elizabeth I. From 1580 he used the castle as a supply of building materials, and in particular used the stone facing blocks to build Berkhamsted Place (now demolished) nearby. A castle as

old as this one is bound to be dilapidated, but its sorry state can largely be laid at the door of Sir Edward.

There are some who might also call the other two changes vandalism, though they did provide public benefits, perhaps to you if you are reading this book as you travel on a train or a canal barge. The Grand Junction Canal (now the Grand Union Canal) was built in the 1790s, and at Berkhamsted it is immediately to the left of the line. As with so many canals, the supply of water is a problem and the springs that supplied water to the castle's moats were diverted to supply the canal instead. The moats do occasionally contain water, but it is now very unusual. Having said that, I visited just after one of the wettest periods, in the wettest year in England since records began in 1910. The moats were full of water, but you may have to wait a long time to see it.

The building of the railway in 1838 was the reason for the third change. Its route slices across the edge of the site, cutting off the south-western side of the outer moat. The barbican had already been taken by Sir Edward Grey but its foundations are under the railway line. So the canal and the railway explain why you are likely to see a dry single moat instead of a wet double one. It is progress, but still a shame.

Windsor and Warwick (among others) were built at about the same time. They are magnificent castles and magnificent tourist attractions, but their original features have been obliterated by later development. Berkhamsted was effectively abandoned in 1495 and this has not happened. Almost uniquely you can really see the original eleventh-century earthworks as seen by William the Conqueror.

Berkhamsted Castle is managed by English Heritage. It is an open monument and entry is free. It is open from 10.00 a.m. until 6.00 p.m. from April to September and from 10.00 a.m. until 4.00 p.m. from October to March.

The Bridgewater Monument

The Bridgewater Monument is high in the hills to the right-hand side of the track. Only the top part of the monument is visible because the bottom is obscured by trees. It is almost level with Tring station and can be seen during the approach to the station.

The Bridgewater Monument is on the Ashridge estate. It is 108 feet tall and made of Aberdeen granite blocks on a plinth of York stone. The vase at the top is made of copper on a framework of wrought iron. There are two steps at the entrance, then 170 steps up to the viewing platform around the vase. The architect was Sir Jeffrey Wyattville. The inscription on the base reads, 'In honour of Francis, Third Duke of Bridgewater, "Father of Inland Navigation", 1832.'

'Father of Inland Navigation' is a very far-reaching statement and could lead one to assume that the Duke was responsible for much of Britain's canal system, including the Grand Union, which runs close to the railway down below. This is not correct, but he was the pioneer who got it all started and on this basis the claim is justified. In fact it is true to say that he was a key figure in the facilitation of the Industrial Revolution.

He ordered and financed the construction of a pioneering canal from his coal mines at Worsley in Lancashire to the industrial city of Manchester. One of its features was the remarkable and unique stone aqueduct constructed over the River Irwell. The canal was later extended to the River Mersey near Runcorn. Construction was under the supervision of the very highly regarded engineer James Brindley. Roads were terrible at the time, and at best a horse could pull a 1-ton load over them. The same horse was able to tow a 30-ton barge along a canal. Work was started in 1759 and the first section was finished in 1761. The price of coal in Manchester then immediately dropped from 7 pence per ton to 3½ pence per ton.

The 3rd Duke of Bridgewater inherited his title at the very early age of eleven. He was only twenty-three when work on the canal started and twenty-five when the first phase to Manchester was finished. The extension to Runcorn was completed in 1776 when he was forty. He faced massive difficulties and the enterprise almost bankrupted him. During the building he denied himself all luxuries and adopted a frugal lifestyle. The 40-mile-long canal cost £200,000, much of which had to be borrowed. It did, though, ultimately give him an income of £80,000 a year.

As a child he had a poor relationship with his stepfather and was said to be morose, ill-mannered and unhealthy. In his late youth he embarked on a grand tour of Europe. His health improved around this time, but there was only a partial improvement in his manner and he never did acquire social graces. During his grand tour he was greatly impressed by Louis XIV's Languodoc Canal, which linked the Bay of Biscay with the Mediterranean and had been completed in 1681.

At an early age he was engaged to a well-known beauty, but sadly for him the engagement was broken off. He never considered another and died a bachelor at the

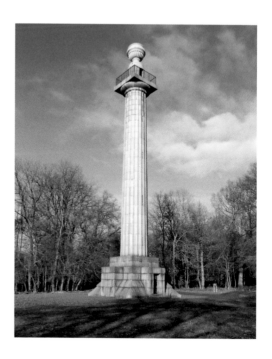

The Bridgewater Monument near Tring.

age of sixty-six. Perhaps a wife would have helped him. Despite his awkward manner a lot can be said in his favour, not least his drive and vision. He was a very fair employer and provided houses for his workers. Furthermore, he established Sunday schools and sick clubs, and he set up shops to provide goods for his workers at reasonable prices. This sort of behaviour was distinctly unusual at the time. All in all he seems to have been rather a good egg, even if a taciturn one.

Later in life and with a fortune exceeding £2 million, he set about rebuilding his house and estate of 6,000 acres at Ashridge. These had been very badly neglected while he had been building canals. Unfortunately they were still in a bad way (the house in particular) when he died. It was left to his cousin the 7th Earl of Bridgewater to build the present house.

Ashridge House is now a management college and the estate is owned by the National Trust. The estate, which is no more than 30 miles from London, is in beautiful woodlands and surrounded by glorious countryside. During my visit I saw a small deer and the whole experience was very uplifting. Had it not been winter I might have said that I came away full of the joys of spring. I really do recommend a visit.

On the death of the 7th Earl, the house and estate passed to his brother, who lived in France and did not return. He did though bequeath £13,500 for an obelisk to be erected in memory of the 'Father of Inland Waterways'. This is the Bridgewater Monument, which was erected in 1832. It is sited well away from the house and this is said to be because the widow of the 7th Earl did not like the design and did not want to look at it. If this is true, she did us a favour because we would not otherwise be able to see it from the railway and the wonderful view from the platform would have been inferior.

The Ashridge Estate is located 2 miles from Berkhamsted on the B4056 Berkhamsted to Dunstable road. Admission is free and there is a tasteful visitor centre and café. The monument may be climbed at weekends and on bank holidays between spring and autumn.

Tring Cutting

Tring Cutting is 2½ miles long and starts immediately after Tring station. The cutting slices through the Chiltern Hills and accounts for $\frac{1}{46}$ of the distance from Euston to Birmingham New Street. Completed in 1838, it is 40 feet deep for much of its length, and during its construction slightly more than 1.2 million cubic yards of soil, chalk and rock were excavated. The term for this is 'spoil', and there was a lot of it.

The gradient through the cutting is a gentle 1 in 330, and in order to permit a double track it was constructed to a width of 18 yards at rail level. Except where blasting was required, digging was done manually, using wheelbarrows and shovels. Barrow runs every 25 yards took the spoil up the side to waiting horses and carts at the top. It was then distributed over a wide area, with some of it used as the basis for the long embankment leading to Leighton Buzzard.

This feat of manual work was accomplished by navvies – the term is derived from 'navigators' – who were the men who dug the canals towards the end of the previous century. Building railways was very labour intensive, especially the cuttings and tunnels, and the work depended on these remarkable men. The Irish were well represented, but most of them were English. They lived in shanty towns near the lines and moved on to a new location when a section of the track was complete. Their living conditions and sanitary arrangements were generally awful. Safety standards were notoriously poor and they suffered many accidents, including a distressingly large number of fatal ones.

The population generally welcomed the coming of the railways, but dreaded the arrival of the navvies that was an inescapable precursor. They were hard-drinking men, prone to fighting and sometimes unruly. They often had a bad relationship with local residents and other workers. This was a shame because they achieved so much and had many admirable qualities. Despite their reputation, some of them at least were upright, sober citizens.

They were well paid by the standards of the time and earned much more than most factory workers. This was because they worked very hard, did a valuable job and were worth it. Five shillings a day was a typical wage. Their work was highly regarded and many of them went on to work in Europe.

Tring Cutting.

Mentmore Towers

Mentmore Towers is a large and imposing country mansion that can be seen from Cheddington station and from a very short distance before and afterwards. It is on the left-hand side about 1½ miles from the station, and it is necessary to look forward. The house is on a hill, at the side of woodlands and at the end of a long, straight road. It looks particularly impressive when the sun is shining directly on it.

Mentmore Towers will forever be associated with the names Rothschild and Rosebery. In its Victorian and Edwardian heyday it was one of the great houses owned and visited by the aristocracy, leading politicians and other members of what was termed 'society'. It was a world familiar to anyone who has seen the film *Gosford Park* or watched the television series *Downton Abbey*. William Gladstone was a visitor, and in the five years up to 1905 a youthful Winston Churchill spent quite a bit of time there.

It is one of the very fine Rothschild houses built in or near the Vale of Aylesbury. Others are at Waddesdon, Tring, Halton, Aston Clinton and Wing. Mentmore was built in 1852–54 for Baron Mayer Amschel de Rothschild. The architects were G. H. Stokes and Joseph Paxton, famous for his Crystal Palace at the Great Exhibition of 1851 and for his work at Chatsworth. Mentmore was designed and built in the Elizabethan style with a turreted roofline and great windows.

Archibald Philip Primrose, 5th Earl of Rosebery, lived at Mentmore from 1878, when he married Hannah Rothschild, until his death in 1929. Books about Lord Rosebery invariably include two anecdotes. One is that he requested that the Eton Boating Song be played on the gramophone at the point of his death. The second is that as a young man he said that his three ambitions were to marry an heiress, win the Derby and be Prime Minister. The first story is true and the record was duly played. The second is probably true, though he always denied it. Be that as it may, the three ambitions were achieved. He actually won the Derby three times, and two of his horses, Ladas and Sir Visto, won the Derby in the sixteen-month period in 1894/95 that he was Prime Minister. His time as Prime Minister was not a happy one and many believe that he was one of Britain's least successful premiers.

Rosebery had a substantial fortune of his own and he married for love rather than money when he wed Hannah, the only child of Baron Meyer Amschel de Rothschild. Hannah brought a fortune of £2 million, which converted into present-day money would put her very high on the *Sunday Times* Rich List. She was a remarkable woman, devoted to him and a great help to his political career. Sadly she died in 1890, having given him four children. This happened four years before he became Prime Minister and he was never quite the same man.

The marriage was controversial because Rosebery was an Anglican and Hannah was Jewish. Rosebery's mother, the Duchess of Cleveland, did not attend the twin ceremonies, one in each faith, and there was adverse comment in the Jewish press. They observed their separate religions throughout their twelve-year marriage.

Mentmore Towers was not just an imposing building; it contained an array of very fine and expensive works of art, and a collection of equally luxurious furniture. In

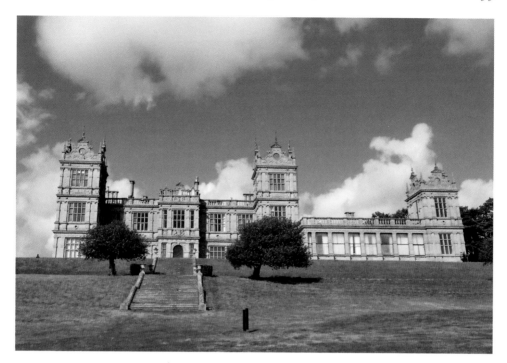

Mentmore Towers near Leighton Buzzard.

the 1920s the former Prime Minister gave the estate to his son Harry, Lord Dalmeny, who on the death of his father in 1929 became the 6th Earl. The new owner shared his father's love of horse racing and he became the proud owner of two further Derby winners, both bred at his Mentmore stud farms. During the Second World War he had the honour of housing the gold state coach, which was moved to Mentmore to protect it from the London bombing.

The 6th Earl died in 1973 and the government turned down an opportunity to create an outstanding museum of European furniture, *objets d'art* and architecture. It was offered the house and its contents for £2 million in lieu of inheritance tax but, in a decision regretted to this day, it said no thank you. Three years later the contents of the estate were put up for public auction. Paintings by Reynolds and Gainsborough were sold with thousands of other objects, large and small. A friend of mine enjoyed a fascinating day out and managed to buy a small and relatively inexpensive memento. The sale raised a sum just over £6 million.

Mentmore Towers was sold in 1977 to the Transcendental Meditation Movement. This was indelibly linked to Maharishi Mahesh Yogi, who had earlier leapt to fame by attracting the Beatles to his philosophy and methods. The house became the movement's national headquarters and was used for residential courses in transcendental meditation. Around a hundred young men were moved to the property to maintain continuous group practice of the TM-Sidhi Programme, and there were many banquets to engage the interest of influential people.

In 1992 the Maharishi made Mentmore the headquarters of the Natural Law Party, which fielded over 300 candidates at the general election of that year. Beatle George Harrison helped launch the political campaign with a concert at the Royal Albert Hall. Depending on your age and interests you may remember the Natural Law Party's election broadcasts, which featured so-called yogic flyers bouncing across the floor. The electorate was entertained but not persuaded and all the party's candidates lost their deposit.

In 1997 Mentmore Towers was sold to a property company, which had plans to turn it into a six-star hotel. The proposals were exciting and if implemented would have made it one of the very best hotels in the country. However, planning and financial difficulties intervened and the idea is on indefinite hold. The house is now empty.

Mentmore Towers is located in the exceptionally pretty village of Mentmore and is not open to the public.

Bridego Bridge:
Scene of the Great Train Robbery

Bridego Bridge is positioned just short of halfway between Cheddington and Leighton Buzzard. You will be able to pick it out by the narrow road that runs underneath it at right angles. There is a large pond immediately after the bridge, on the left-hand side next to the road. At the right time of year you may see fishermen spaced out around it.

Why is it always known as the Great Train Robbery rather than just the Train Robbery? After all there have been many big robberies since, and there have certainly been more violent ones. It is of course partly due to the huge amount of money stolen – £2,631,634. It sounds a lot even today and it seemed an incredible sum in 1963. To put it into perspective, Johnny Haynes had just become the first footballer in Britain to earn £100 a week. It is also the sheer daring and audacity of the two gangs that combined to make a total of sixteen robbers on the embankment.

For whatever reason, the Great Train Robbery certainly gripped the public's imagination. It is unerringly recalled as a landmark of the 1960s, alongside the Profumo scandal that was raging at the same time and England's World Cup victory three years later. Names such as Ronald Biggs, Buster Edwards and Bruce Reynolds are almost as familiar as those of Bobby Moore, Christine Keeler and Harold Wilson. Right from the start the British people were divided. Some people thought that it was outrageous criminal behaviour and wanted the perpetrators quickly caught and punished. On the other hand a surprisingly large number felt at least some admiration for the robbers and were pleased at the snub to the establishment. Many quite erroneously saw it as a victimless crime, or even better a crime where the only victims were the banks and the insurance companies. There were no guns and not much violence, despite the unplanned coshing of the train driver. Later there was widespread disapproval of the extraordinarily long jail sentences, even though, predictably, they were not actually served.

Bridego Bridge was chosen partly because of its remote location, and even today there is a feeling of desolation. This is even more pronounced in the middle of the night, and in the unlikely event of a nocturnal visit you may perhaps sense a few ghosts on the embankment.

The robbery took place in the early morning of Thursday 8 August 1963 and it of course depended on detailed inside information. Contrary to speculation that the robbers were surprised at the amount of their haul, Bruce Reynolds says in his autobiography that they were expecting anything up to six million pounds. The train had started from Glasgow and picked up mail along the route. It was a long train with seventy workers sorting the normal mail, but the first two coaches were for high value packages containing banknotes.

Doctored signals made the train stop at Sears Crossing, which is 800 yards up the track from the bridge. Jack Mills, the driver, and his fireman were overpowered and, in the robbery's only violence, Mills was coshed. The engine and the front two coaches were detached from the rest of the train and the gang's driver attempted to move the engine on. He failed, so Mills was coerced into driving down to Bridego Bridge. At the bridge the gang smashed their way into the coaches and passed the sacks down the embankment via a human chain to a waiting lorry. After just a few minutes the lorry and accompanying Land Rovers sped off into the night. Their destination was Leatherslade Farm, 27 miles to the west, which had been purchased so that the gang could lie low and divide up their ill-gotten gains.

Bridego Bridge near Leighton Buzzard.

The finest of more than one constabulary were allocated to the case. Bridego Bridge is in Buckinghamshire, just over the Bedfordshire border and a few miles before the track runs into Hertfordshire. This ensured that, much to their annoyance, the Buckinghamshire ratepayers picked up many of the costs of the investigation and the subsequent trials. Under the direction of Chief Constable Brigadier John Cheney, Detective Superintendent Malcolm Fewtrell postponed his impending retirement and led the provincial force. Chief Superintendent Tommy Butler and Detective Superintendent Gerald McArthur led Scotland Yard's Flying Squad.

The police did a very good job in quickly identifying most of the robbers, though detaining some of them took much longer. It was, though, not a hard crime to solve. The execution of the robbery at Sears Crossing and Bridego Bridge had gone almost exactly to plan, but mistakes had been made before and afterwards. Luck too played a part. A large number of people had been involved, which made it difficult to keep secrets. Many gang members had told their wives or girlfriends. An enormous reward encouraged informers and, above all, only a small number of gangs and criminals were capable of planning and carrying out this particular robbery. The robbers had 'form' and the police knew exactly where to start looking.

Events moved quickly. On 13 August the abandoned Leatherslade Farm was discovered and it swiftly revealed an abundance of fingerprint and forensic evidence. On 14 August the first two arrests were made and a day later the press published nineteen names. On 19 August another arrest was made, and this was followed by the police interviewing Ronald Biggs. A wanted poster featuring nine names and photographs was published and in the following weeks there were many arrests, the last one being on 11 December.

The first and biggest of the trials opened at Aylesbury on 20 January 1964. It is worth taking a moment to reflect on the date, which was just 165 days after the robbery and 40 days after the last arrest. It would undoubtedly take much longer now. Following the retrial of Ronald Biggs, twelve men were convicted. Seven were sentenced to thirty years, one to twenty-four years, one to twenty years and the others to lesser periods. Severe sentences had been anticipated but there were audible gasps as they were delivered. As the prisoners were taken down, a prison officer said to them 'Don't worry lads, you'll never serve them,' and of course he was quite right. They actually served around a third before being released on licence.

This was not the end of the story, which rumbles on to this day. The rest of the gang went into hiding and were progressively arrested, convicted and sentenced, although three of the robbers, including (probably) the one who coshed the driver, have never been named or convicted. Charlie Wilson and Ronald Biggs sensationally escaped from prison and others plotted to do so. Wilson was detained in Canada three years later. With great style, he offered a cup of tea to Chief Supt Butler, who knocked at his door. Shortly afterwards, and just before his retirement, Butler had the satisfaction of arresting Bruce Reynolds, who was arguably the biggest catch of all.

Few of the robbers prospered and in subsequent years many appeared short of money. Several were convicted of later crimes and Charlie Wilson was murdered in Spain, probably by gangsters. Buster Edwards committed suicide after running a flower

stall outside Waterloo station for seventeen years. Ronald Biggs returned to England in 2001 after thirty-six years on the run. For much of this time he had contributed to the gaiety of nations with his antics beyond the reach of the law in Rio de Janeiro. In desperately bad health he hoped to spend his last days in freedom with visits to Margate as a treat. His wish was not granted and he was returned to prison.

It is quite a story and there is only one thing at the bridge to show that it was the scene of the robbery. It bears the number 127 and there is a small plate to say that it is bridge 'LEC1/127 Train Robbery (Off B488)'. This is followed by a telephone number and is to help identify the bridge if damage is being reported. The bridge is about 200 yards from the B488 road, which runs parallel to the railway line. It is 1.7 miles from the Leighton Buzzard bypass, and in the other direction towards Cheddington it is 1 mile from the hamlet of Horton.

Leighton Buzzard: All Saints Parish Church

Leighton Buzzard All Saints parish church is in the centre of the town, on the right-hand side of the line and ½ mile from the station. It should not be confused with St Barnabas church, which is right next to the station. The tip of the spire can first be glimpsed from a point just beyond Cheddington station and, with one or two interruptions, some or all of it can be seen through all of the 3 miles to Leighton Buzzard station. It is necessary to look forward on the right-hand side. The spire is floodlit after dark, which makes it a sight to behold. Each winter's night hundreds of Leighton Buzzard commuters put away their papers and reach for their cases when they see it.

The main part of the church is well worth describing and this follows later, but only the spire can be seen from the railway line so it is appropriate that this should have pride of place and come first. It is a humbling thought that if you could travel back in time to the year 1350, you would see, minus the weather vane and the pinnacles, almost exactly what you see now from this spot.

The spire is made from oolitic limestone that is believed to have been quarried near Oxford. It was built in the 1340s and finished by 1350, but the pinnacles were added in 1842. It is 191 feet high and bulges slightly outwards so that from a distance it might look straight. Two of its hypothetical nine lives were used up in 1852 and 1985. On the first of these two dates it was struck by lightning and the top 20 feet had to be replaced. In 1985 a disastrous fire (more of this later) resulted in its thickness being reduced from 9 inches to 4 inches. It was thought that the spire would collapse but some very skilful restoration work managed to save it. This involved replacing some 400 of the stones, but the original structure erected in the 1340s is still there.

These are the facts and figures, but it is worth putting them aside and just reflecting on the extraordinary achievement. For a start, transporting the building materials from Oxford would have been a major task, and the builders did not have the benefit

of modern tools, electricity, cranes, scaffolding and the like. Yet they managed to haul the stones 191 feet into the sky and build something solid and beautiful that has lasted more than 660 years and is set for many more.

It is also worth contemplating with reverence (an appropriate word in the circumstances) the proportion of the available resources that would have been committed to it. Leighton Buzzard then had a population of about 600 and for most of them life was grim and short. It must have been the equivalent of rebuilding Wembley Stadium in our own time. Of course almost all of the 600 would have had little or no say, but it did provide paid work for some of them. They took God and their religion seriously in those days.

No less a person than John Betjeman, the Poet Laureate, was of the opinion that the church was the finest in Bedfordshire. His views on buildings and architecture are worth taking seriously and he could offer criticism as well as praise. Who can forget his poem 'Slough', published in 1937? It includes the oft-quoted words:

> Come friendly bombs, and fall on Slough!
> It isn't fit for humans now.

The Domesday Book records that there had been a church on the site since the reign of Edward the Confessor, who came to the throne in 1042, but the main part of the present building was constructed fifty or so years before the spire, probably in the 1280s. There have been three significant additions: The two-storey vestry building was added early in the sixteenth century; the three porches to the main church were added during the seventeenth century; and the two-storey extension on the north side, which is constructed of local sandstone, was built in the 1990s after the fire and replaced a single-storey vestry built in the early 1900s.

The church itself has far too many interesting features to describe, but just a few should be mentioned. If you visit, you are likely to notice the high angel roof of the nave, which was added in the fifteenth century and carefully restored after the 1985 fire. This was added at the expense of Alice de la Pole, Duchess of Suffolk, who was the grand-daughter of Geoffrey Chaucer. You will probably notice or have your attention drawn to the twenty-five ferocious gargoyles, the five sundials and the ironwork on the outer west door. The latter is the work of Thomas de Leighton, who made the iron grill for the tomb of Queen Eleanor in Westminster Abbey in 1294. A prominent internal feature is the pulpit, which is made of red cedar and was given to the church in 1638. Another is the tower altar which is made of limestone and weighs 3.4 tons. A new ring of twelve bells (thirteen with the sharp second) was cast by Taylors of Loughborough after the fire. Each bell carries the name of one of the apostles, with the thirteenth dedicated to St Paul.

The fire took place on 13 April 1985, and it was a really big one. It could not have happened at a more unfortunate time because a major (and expensive) restoration programme was close to completion. It destroyed much of the nave and chancel roofs and caused serious structural damage to the spire, tower and vestry areas. The clock was lost, as was the ring of ten bells, the organ in the crossing and the choir

All Saints parish church at Leighton Buzzard.

organ. The medieval sanctus bell, dating from about 1150 and the oldest bell in the St Albans diocese, fell through the tower floor. The total cost of the damage exceeded £2 million, and a new restoration programme was immediately started. Much has been achieved but there is still work to do. There is an ongoing need for funds and any contributions are gratefully received. £500,000 is now being raised for the final phases of the work.

The All Saints parish church is splendid and of course very old. The list of vicars dates right back to Thomas de Kyrlington, who was appointed in 1277. It could have turned into just a semi-museum but this has not happened. It is today, as for so long, an active, thriving, Anglican parish church.

The church welcomes visitors, particularly of course to join in services. There are no guarantees but it is likely to be open from 9.00 a.m. until at least 2.30 p.m. and sometimes later. The office telephone number (mornings only) is 01525 381418. There is an exceptionally good coffee shop, frequently patronised by me, that specialises in homemade cakes. This is open from 10.00 a.m. until 3.30 p.m. on Tuesdays, Fridays and Saturdays.

If a visit to the church is made, it is worth spending a few minutes reflecting on the war memorial that stands outside. It consists of a large granite block, 25 feet 3 inches in height, 3 feet 2 inches square and weighing 22 tons. The granite block is the largest ever quarried in Britain. It was taken from Shap Quarry in the Lake District in about

1870, and had laid unused in a builder's yard in Westminster for fifty years before being taken to Leighton Buzzard.

The memorial was unveiled on 11 November 1920 by Lord Ampthill. Four former officers, one of them blind, stood in uniform at each corner. Contemporary accounts said that 5,000 people were crammed into Church Square and the surrounding area. Crowds are very difficult to estimate and frequently overstated, but photographs certainly show a very large number. The memorial lists 171 names of those who died in the First World War, fifty-one who died in the Second World War and one who died in the Korean War. As is normal and proper, the names are listed in alphabetical order.

In my frequent visits to the church for coffee I sometimes look at the memorial and think about what it means. Everyone has their own thoughts, but I often think of the wives and mothers looking for the telegraph boy and praying that he will pass by.

Old Linslade: Church of St Mary the Virgin

Shortly after Leighton Buzzard station the train passes through a tunnel. Soon after leaving the tunnel the church of St Mary the Virgin can be seen on a mound on the right-hand side. There is a graveyard in front and it is about 200 yards from the track. I have been told that occasional train announcements have referred to the train passing 'cemetery ridge', which makes it sound more like a First World War battlefield than a fascinating and pretty church.

Another church, and just a mile up the road from All Saints parish church in Leighton Buzzard! It's a bit like buses; there is a long wait and then two come along together. In this instance we are fortunate that they do, because the church of St Mary the Virgin in Old Linslade is another very old church having many splendid features and contents, and with a fascinating history.

What is the oldest building in Leighton-Linslade? Many people, and indeed some books, say that it is All Saints parish church in Leighton. They are wrong, but it would have been an understandable answer until 1965. This is because in that year Leighton Buzzard Urban District (in Bedfordshire) was merged with Linslade Urban District (in Buckinghamshire). Much to the annoyance of the good people of Linslade the resulting Leighton-Linslade Urban District was placed in Bedfordshire. So both All Saints and St Mary's are in Leighton-Linslade. St Mary's is the older by more than 100 years.

The first stone church on the site was built in the middle of the twelfth century, and elements of it can still be seen today. At its earliest, it dates from between 1165 and 1179. It was in a small village that has since disappeared. In the Domesday Book of 1086 Linslade was described as a manor with a mill and a population of about 150 villagers. The first recorded vicar of the church was Henricus, who was appointed in 1247, though there would have been others before that date.

From 1251 the village had a market every Thursday and an annual eight-day fair. This was held on the feast day of the Nativity of St Mary, which was 8 September, and on the preceding day and the subsequent six days. It appears that the village of

Linslade flourished and that one of the reasons for this was the nearby presence of a holy well, which was believed to have healing properties and attracted visitors who brought trade and money. The pilgrimages were encouraged by the vicar. This was stopped by an order of the Bishop of Lincoln in 1299 and, even worse, he called the vicar to appear at an Archdeaconry Court. Apparently he felt that things were getting out of hand, but could he have been jealous? Or might there be some other reason?

The present church is very like the original and incorporates parts of it, particularly some of the stonework in the walls. Like the first church there is a nave and chancel, but the tower was added in the mid-fifteenth century. It may once have been topped with a spire. A gallery was added in 1820, but it was removed in 1876.

The isolated situation of St Mary's can be attributed to the coming of the canal in 1800, and especially to the coming of the railway in 1838. Leighton Buzzard station is actually in Linslade, close to the Leighton border. The town of Linslade developed in this area and away from Old Linslade. By the 1840s the church was in a poor state of repair and many of the parishioners lived some way away. This led to the decision to build the new church of St Barnabas close to the station. This seated more than 500 and was opened in 1848. St Mary's was virtually abandoned and fell into disrepair.

Emergency repairs were carried out in the 1870s and major restoration work was done in 1897. This included reroofing the church and the work was done to commemorate Queen Victoria's Diamond Jubilee. No doubt Her Majesty was suitably pleased. The whole of the considerable cost was borne by Henry Finch, a wealthy local businessman.

The church of St Mary the Virgin at Old Linslade.

The nave is 45 feet long and 24 feet wide, and my first impression on seeing the inside of the church was that it was small. However, the word compact perhaps conveys a more suitable impression. It is, though, only a fraction of the size of St Barnabas, which replaced it. St Barnabas illustrates the hold and confidence of the church when it was built in 1848; for a population of less than 1,300, 500 seats were provided.

During my visit, a churchwarden very kindly showed me round and let me have a very informative guidebook by Maureen Brown. Some of the details in this section are sourced from this book. For an enthusiast there is much to study in the church but, enthusiast or not, it is difficult (in a nice way) not to feel the weight of history. For example a little graffiti includes '*a jesu helpe*', which it is believed may have been written at the time of the Black Death in 1348–50. This is sometimes said to have decimated the local population, but taken literally decimate means to kill one in every ten, whereas in fact up to half of the local people died.

The abiding memory of my visit is the font, which is dated to around the year 1210. To put this into context, it is 40 per cent of the way back to the birth of Christ. It is a humbling thought, which leads me to wonder what we are leaving now to be admired in 800 years time. The font stands waist high and is both bulky and very heavy. It consists of a semicircular bowl, supported by an octagonal stem and moulded octagonal base on a circular plinth. The bowl is surrounded by a carved band containing images of four grotesque beasts with richly foliated tails and bunches of foliage between them. It is cracked and repaired in one place, but I cannot see why it should not last for another 800 years. I hope so.

St Mary's is part of the parish of Linslade and is administered from St Barnabas church in Linslade. It hosts a communion service on the first Saturday of each month and there are occasional other services. One fixture is a dawn service held every Easter Sunday. Not surprisingly the church is popular for weddings and funerals. Admirably, and again not surprisingly, it is served by a band of volunteers.

Bletchley Park:
Home of the Codebreakers

Bletchley Park is on the left side of the track and within 200 yards of Bletchley station. The brief view is from the far end of the platform and just beyond. The boundary trees and a white building, which are over a road, are visible from the train.

You are 200 yards from the place where brilliant and dedicated codebreakers made a vital contribution to winning the Second World War. Bletchley Park is now open to the public and has much to offer.

You may well have heard the claim that the work at Bletchley Park shortened the war by a number of years. Two years is the most common assertion, but some historians say by up to four years. You would be right to be sceptical about a precise period because there are so many variables and no one can say. It is true, though, that the work of the

codebreakers at Bletchley Park was extremely valuable, did shorten the war and did save many British and Allied lives. It is also true that the codebreakers were both clever and dedicated, and that a large number of people maintained absolute secrecy both during and after the war.

In 1883 Bletchley Park became the home of Sir Herbert Leon and his family. Sir Herbert was a London financier, friend of Lloyd George, and for a while the Liberal MP for North Buckinghamshire. He was a respected man who over a number of years improved the mansion and the estate.

By 1938 Sir Herbert was long gone, but the mansion and the estate that he left were available and ideal for the planned war work. Britain's codebreakers were then based in London and vulnerable to the anticipated German bombing. A suitable location away from London was wanted and Bletchley Park fitted the bill. So Admiral Sir Hugh Sinclair, Director of Naval Intelligence and head of MI6, bought it. The mansion and some unprepossessing huts subsequently erected were to house the codebreakers.

The first group of the Government Code & Cypher School (GC&CS) moved to Bletchley Park on 15 August 1939. The genius Alan Turing, who became the most famous of the codebreakers, arrived on 4 September. He deserves his fame, but it should not be forgotten that he was one of several brilliant people. Nor should it be forgotten that the numbers built up until there were a considerable group of people working at Bletchley, most of them giving mundane but vital clerical support. Many of them were WRENS and other young women.

The most notable achievement concerned the German Enigma machines. These had 150 million million million possible settings, and if used correctly the codes were virtually unbreakable. Fortunately the operators sometimes did not use them correctly, which allowed the codebreakers to 'get in'. They did it by using mathematical principles.

The first breakthrough came on 20 January 1940, and it was achieved by a team under Dilly Knox that included Alan Turing and John Jeffreys. Shortly afterwards Bletchley Park was swamped with intercepted material to decode. The vital information was often buried in a mass of trivia. This resulted in the build-up of resources and staff. At its peak in January 1945, 9,000 people worked at Bletchley.

The process of breaking Enigma was greatly enhanced by an electro-mechanical device named the Bombe, designed by Alan Turing and Gordon Welchman. The first of them was delivered on 18 March 1940 and the design was subsequently improved. During the course of the war more than 200 were built. The Bombes enabled vast numbers of mathematical calculations to be done very quickly.

It took a while for the material obtained to be trusted by the generals and admirals. This was perhaps understandable because they could not be told how it had been obtained. However, the intelligence was extremely helpful in defeating the German U-boats that were sinking merchant shipping in the North Atlantic. It also helped in countering the Luftwaffe and in the 1942 North Africa campaign. In time Japanese codes were also broken.

In early 1942 the U-boats introduced a more complex Enigma cipher and for a time the codes could not be broken, but the problem had been solved by the end of the year.

Bletchley Park.

There was a stunning development in the following year. Tommy Flowers and his team built Colossus, the world's first programmable electronic computer. This was operational in December 1943 and stepped up the level of what could be achieved. Flowers, Turing and the mathematician Max Newman are credited as the fathers of the modern computer. The amount and quality of the decoded material helped the Allied war effort enormously. Just one example was in the planning for D-Day in June 1944. This was done with very considerable knowledge of the German defences, and after misleading Hitler about where the landings would take place. Bletchley had an important part in all of this.

Churchill said that the Bletchley Park workers were, 'The geese that laid the golden eggs – but never cackled'. We have studied the golden eggs and it is now time to say something about the absence of cackling. This was, of course, crucial. The Germans believed that the Enigma codes were unbroken and unbreakable, and they maintained this belief until the end of the war. Had they come to think otherwise they would have made fundamental changes. At best this would have been a severe setback, and at worst it would have brought Bletchley's contribution in this respect to an end. 'Careless Talk Costs Lives' – it was one of the most famous posters of the war, and it was true. Secrecy was taken very seriously indeed. Over the course of the war 12,000 people worked at Bletchley Park and they all signed the Official Secrets Act.

Care had to be factored into the planning of military operations. Had deployments been too obviously influenced by knowledge obtained from codebreaking, the enemy might have been alerted. A further factor was that the Germans were led to wrongly believe that a very effective network of spies was operating within Germany.

Perhaps even more remarkably, the secrets were maintained for thirty years after the war, when the need for secrecy was not so apparent. The work only became public knowledge in 1974 with the publication of F. W. Winterbotham's book *The Ultra Secret*. During that time quite a few heroes had died without their families and friends knowing what they had done. Some of the survivors thought that the book was a betrayal and should not have been published.

Bletchley Park was closed down soon after the end of the war, but with the advent of the Cold War the need for codebreaking remained. The work continues to this day at Government Communications Headquarters (GCHQ) at Cheltenham. Ironically the secrecy surrounding Bletchley Park counted against it after the war. It was almost turned into a housing estate because so few people knew of its significance. Fortunately this did not happen and in the year 2000 a new Trust Board took over. It is now open to the public and I recently spent a very enjoyable and interesting half day there. I do recommend it.

Your visit can include a guided tour and you may learn much about computing, codebreaking and what was done there. One impression that I took away was just how basic the huts are – very 1940s, which I suppose should not be surprising because they were erected in the 1940s. A main feature is the Block B Museum, which tells the complete Bletchley Park story. The souvenir guide book details other exhibitions and collections.

I also enjoyed the model railway exhibition, the toys and memorabilia collection and a collection of vintage vehicles. All three of these are only open at weekends. Another 'must see' is the National Museum of Computing, which is open throughout the week. This traces the development of the computer from Colossus (developed at Bletchley) through to the present day.

There are many other attractions and special events are held from time to time. All details are available on the website: www.bletchleypark.org.uk or by ringing 01908 640404. It is also worth mentioning that Bletchley Park is a licensed wedding venue.

If you do go, have a good time and think of the people who worked there. I am sure that you will. You can take satisfaction from the fact that you are supporting a very good cause. The Trust receives no public funding and has ambitious plans for the future.

MK Dons Stadium:
The House That Pete Built

MK Dons' Stadium is on the right side of the track and can be seen from about half a mile beyond Bletchley station. The upper part of the stadium can also be seen a little further on. From this point it is necessary to look backwards over some buildings. The final view is from a bridge looking down a major road.

Many readers will spot the allusion in the title of this section to 'The House That Jack Built', a traditional and very old children's poem. Americans, on the other hand, will probably think of the baseball stadium of the New York Yankees, opened in 1923 and immediately dubbed 'The House That Ruth Built'. Ruth was Babe Ruth, still the most revered baseball player of all time. He was a left-handed hitter and famous for slugging a record number of home runs. The Yankees had other left-handed hitters too.

Yankee Stadium was designed to help Ruth and the other left-handers. A right-handed hitter naturally pulls the ball to the left and it was 350 feet to the boundary in that corner. A left-handed hitter, on the other hand, naturally pulls the ball to the right, and it was only 290 feet that way. It was a big advantage and, to my mind at least, not sporting, but when did money and sporting behaviour ever have anything in common? I cannot think of another sport that permits playing areas that are not symmetrical. Cricket does not count because the bowling alternates from end to end.

So far so interesting, at least to me, but why is it relevant to MK Dons? And who is Pete? To take the second question first, Pete is Pete Winkelman. He is chairman of MK Dons Football Club, managing director of the property development consortium Inter MK and owner of Linford Manor Studios. His earlier career was in pop music production as a CBS executive. Mr Winkelman does not play football, but he did play a leading part in getting Wimbledon Football Club to relocate to Milton Keynes. This controversial move made him something of a hero in Milton Keynes, but not kindly regarded in Wimbledon.

Wimbledon Football Club was elected to the Football League following the 1976/77 season, and its subsequent success was both rapid and remarkable. It was promoted to the old first division following the 1985/86 season and won the FA Cup in 1988. However, its ground at Plough Lane was small and not up to standard, and following the Taylor Report on the Hillsborough Stadium Disaster, the club was required to either move or spend a lot of money upgrading it. Not having the necessary money, the club negotiated a ground-sharing arrangement with Crystal Palace. This was 6 miles away at Selhurst Park. The move was intended to be temporary, but the club failed to find a suitable permanent site. Over the next decade, financial difficulties beset the club and it went into administration in June 2003.

Enter Mr Winkelman, who led the Milton Keynes Stadium Consortium, formed in 2000 and supported by Asda and IKEA. The consortium proposed a large-scale development in Milton Keynes to include an Asda hypermarket, an IKEA store, a retail park, a hotel and a 30,000 capacity football stadium. This last part of the proposal was

hindered by the inconvenient fact that the expanding town of Milton Keynes did not have a top-level football club. It did not even have a medium-level football club. The proposed solution was to invite (some would say entice or bribe) a top-level club to move.

Approaches were made to several clubs, but it was the directors of Wimbledon who were receptive to the idea. The consortium promised that Wimbledon's name, badge and colours would be retained. The move was hugely controversial and was initially rejected by the Football League. The rejection was contested, partly on legal grounds, and a commission to examine the matter was set up by the Football Association. In May 2002 this ruled by two votes to one in favour of the move.

The Football Association said that although the decision was final and binding, it strongly opposed the relocation. The FA Chief Executive, Adam Crozier, said that the commission had made an appalling decision. Disaffected supporters formed a new club, AFC Wimbledon. This has had success after success and promotion after promotion. At the time of writing it is safe from relegation, but in the lower part of Division 2 of the Football League. Prior to moving to Milton Keynes the old club went into administration in June 2003.

Mr Winkelman had succeeded, but he was sitting on some big problems. The club did not have a stadium to play in, and initially it was in administration. In fact it only

MK Dons Stadium in Milton Keynes.

played with the permission of the administrator, and his continued support could not be taken for granted. The club remained in administration until Winkelman bought it in 2004. In the 2005/06 season relegation to the fourth tier followed.

On buying the club Winkelman changed its name, badge and colours. In a move bitterly resented in Wimbledon the chosen new name was MK Dons (Milton Keynes Dons to give it its full title). 'Dons' was the nickname of the old club and one view is that it was a tribute to the club's history and prior achievements. MK Dons claimed Wimbledon FC's heritage as its own, but it renounced it in 2007.

Until the new stadium was ready, the club played at the National Hockey Stadium, which was located next to Milton Keynes Central station. The lease on this ran out in May 2007 and the first game in the new stadium (against a young Chelsea XI) was played on 18 July 2007. It was officially opened by the Queen on 29 November 2007.

The stadium was designed by HOK, the same firm of architects that designed the Wembley and Emirates stadiums. The cost was in the region of £50 million, which fortunately was only a fraction of the Wembley cost. It is an all-seater stadium with a capacity of 22,000, the upper tier not being fully developed. It is planned to increase this in the near future, and ultimately to 44,000.

The stadium is two-tiered on three sides of the ground, with the large lower tier overhung by a small upper tier. The west side of the stadium is slightly different. Here the upper tier is replaced by the directors' box and executive and corporate hospitality areas.

The stadium occasionally hosts rugby games. These have included the 2010/11 quarter-final of the Heineken Cup between Northampton Saints and Ulster. This attracted the stadium's record crowd of 21,309. Northampton won and went on to beat USA Perpignan in the semi-final, which also played at the MK Dons stadium.

Representative football matches have been played and on 5 June 2010 the stadium hosted the full international friendly, Ghana v. Latvia.

In December 2009 the English FA awarded 'Candidate Host City' status to Milton Keynes. This related to England's bid to host the 2018 or 2022 World Cups. The bid did not succeed, but had it done so Milton Keynes would have hosted some World Cup games. The stadium has been chosen as the venue for three games in the 2015 Rugby World Cup.

Would you enjoy a visit to the stadium? Perhaps this would depend on which team you support and whether they win or not, but I can tell you that I enjoyed a recent visit in the company of my grandson. There was a nice atmosphere – hard to define, but you will know what I mean. The view of the game was excellent and the facilities were very good. My grandson particularly commends the hot dogs, which are big enough to feed you for a day. It was a very entertaining game, which MK Dons lost, but it did not matter to me because I was there as a neutral, a rare thing in a football stadium.

I came away with just one negative thought. The crowd was 8,700, which is not bad for the level of football in which MK Dons are playing, but it seemed rather lost in such a big arena. The dimensions of the stadium will not change, but the feeling will probably be more pronounced when the capacity is increased to 32,000 and even more so if it goes to 44,000. Of course if MK Dons are in a higher league the problem

will be reduced and if in a few years time they are playing Manchester United in the Premiership, the size of the stadium will be an advantage. At the time of writing they occupy a position mid-table in League One.

Watling Street

You probably know that Watling Street was a Roman road, indeed one of the most famous Roman roads of all. You probably also know that Roman roads tended to be straight and of high quality for their time. Nevertheless, you probably did not expect the Romans to construct a dual carriageway with a crash barrier down the middle. This is what you will see from a bridge over a road a mile beyond Bletchley station, and again when the train emerges from a small cutting a little later. Watling Street is on the left side of the train until it swings off just before Milton Keynes Central station.

The explanation is that what you see is the A5 road, and the modern road builders did not slavishly adhere to Roman dimensions and materials. The A5 follows the course of Watling Street quite closely for a considerable distance. It is never far from the train until the track swings westwards towards Birmingham. You can see Watling Street/A5 again in the approach to Weedon. This time the road is on the right-hand side of the train and it is not a dual carriageway.

Watling Street was originally a track used by the Britons for hundreds of years before the Romans returned to our island in AD 43. The main part of it connected Canterbury in Kent with St Albans in Hertfordshire.

The Romans took it over, paved it and used it to link Dover and Richborough in Kent with London. This generally is the route of the modern A2 road. Watling Street crossed the Thames at a ford near Westminster, then went north-west to a point near Wroxeter in Shropshire. Wroxeter is near Shrewsbury and it was the fourth-largest city in Roman Britain. This generally is the route of the modern A5 road. The Kent coast to Wroxeter is considered to be the route of Watling Street, but roads from Wroxeter into Wales and also to Chester are sometimes taken to be part of it.

The story of the Battle of Watling Street in AD 60 or AD 61 is certainly worth telling. There are inevitably quite a few probablies in it, but what follows represents the consensus of opinion. The battle was between an alliance of indigenous British people led by Boudica and a Roman army led by Gaius Suetonius Paulinus. The Romans were very heavily outnumbered but won a decisive victory that ended resistance to Rome in the southern half of Britain. A Roman historian says that after the battle Boudica poisoned herself.

The precise site of the battle is not known, but it is generally accepted to have been on Watling Street and probably in the Midlands. Claims have been made for a number of sites, but the most plausible are Mancetter near Atherstone, High Cross in Leicestershire and Cuttle Mill near Towcester.

The background is that King Prasutagus ruled the Inceni people with the consent of Rome, but when he died his will was ignored. His lands were seized, his widow

Watling Street (A5) in Milton Keynes.

(Boudica) flogged and their daughters raped. Another tribe joined the Inceni in a vengeful army led by Boudica. While the Roman governor was campaigning in Anglesey they destroyed Colchester (Roman name Camulodunum) and sacked London after the Romans had withdrawn. While Boudica's army attacked St Albans, the governor returned and regrouped his forces. This led to the decisive battle.

If we fast-forward eight centuries, we find Watling Street playing another very important part in our island's story. In 878 Alfred the Great, fresh from burning the cakes, defeated the Viking Guthrun at the Battle of Eddington. The subsequent Treaty of Wedmore required the defeated Danes to withdraw to the northern and eastern parts of England. Danelaw continued in these areas, but not elsewhere. The demarcation line was based roughly on the route of Watling Street. So as your train speeds along you may look out of the window and think that the villages on the right were subject to Danelaw, but that the villages on the left were not.

There are probably more than enough old words in this section of the book, but Welsh Nationalists will love Waecelinga Straet, which is the Roman name for Watling Street. Waecel is possibly a variation of an old English name for 'foreigner'. In the context of the time that meant the Welsh.

Milton Keynes

Milton Keynes is big. It runs from Bletchley and Fenny Stratford in the south to Wolverton and Stony Stratford in the north. This means that seven other sections of this book lie within its boundaries. This part of the book is about Milton Keynes as a whole, and in particular central Milton Keynes. The central area is to the right of Milton Keynes Central station and to the right of the section of the line leading to it.

Mention Milton Keynes in company and you may well get three responses. One of them will be a mention of the famous concrete cows, and a separate section of this book is devoted to them. The second could be that it is difficult to find your way when driving around, and the third might be that there are a lot of trees.

Some of the roads are designated V or H and no V or H road is more than a kilometre from the next one. They are numbered sequentially. V means vertical and there are eleven vertical roads running from north to south. They all end in 'Street', Saxon Street V7 being an example. H means horizontal and there are ten horizontal roads running from east to west. They all end in 'Way', an example being Standing Way H8. There are numerous roads (some of them quite major) that are not part of the grid system. All of the many roundabouts have names, which does help. It sounds logical, and its advocates will explain why it is and fail to understand why anyone has problems.

Right from the beginning Milton Keynes was planned to have many green spaces and many trees, so yes it is true that there are a lot of trees. Milton Keynes is famous for them. You should, though, be sceptical about some of the claims. If you use an internet search engine, you will see some extraordinary numbers – twenty million and nine million each appear several times. It probably depends on how you define a tree and how you define Milton Keynes. Using the biggest possible definition of Milton Keynes (the Unitary Authority) if there are nine million trees, there must on average be one tree in every 37.6 square yards. If there are twenty million trees, there must on average be one tree in every 16.9 square yards, so if the claims for the number of trees are correct, they must be growing very thickly indeed in some places. However, it is true that Milton Keynes is exceptionally green and that there are a remarkable number of trees.

Milton Keynes can be called a new town, though it is now mature. In the 1960s the government decided that a number of new towns were needed and the decision was made that the largest of them would be located in north Buckinghamshire. It came to pass and many people believe that Milton Keynes is the most successful of them all, as well as the biggest. The chosen area lay between Watling Street (the A5) and the railway line on which you are travelling on the western side, and the M1 Motorway on the eastern side. It would eventually encompass the relatively small towns of Bletchley and Fenny Stratford in the south and the relatively small towns of Stony Stratford and Wolverton in the north. In the middle were a number of small villages, including the tiny and very pretty one of Milton Keynes. This is the one that gave its name to the new town.

Milton Keynes Development Council (MKDC) was set up and charged with making it happen. The signing of papers and go-ahead to build was on 23 January 1967, and

MKDC was told to make it a city in scale. This has caused some confusion because it is not a city, although it is frequently referred to as one. Failed attempts to gain city status were made in 2000, 2002 and 2012. MKDC was wound up in 1992 after twenty-five years and this part of North Bucks is sleepy no more. The population of the area covered by the Unitary Authority was 248,000 in the 2011 census. In 1961 it was 53,000.

So much for the development of the place. Now let's have a closer look at some of the things that it has to offer.

Harold Wilson once said that he was particularly proud of two achievements during his time as Prime Minister. One was that he was premier during the only year since the Second World War when no British servicemen died on active duty, 1968. The other achievement was the establishment of the Open University. Wilson appointed Aneurin Bevan's widow Jennie Lee as Minister of the Arts with responsibility for setting up the Open University. She faced a lot of hostility and much indifference (even though these responses are contradictory), but she was relentless and forced it through. Almost everyone agrees with Wilson's assessment and thinks that it has been a great success. Milton Keynes was the chosen location and the Open University set up shop there in September 1969 with just over seventy staff. It got going very quickly and 25,000 students were enrolled in January 1971. It is the largest academic institution in the UK, and more than 250,000 students are currently enrolled. There are close to 7,000 academic staff and more than 3,500 support and administrative staff. To this day its headquarters are in Walton Hall, Milton Keynes.

Building bigger and better shopping centres seems to have become a national obsession. Despite all the new ones, the Milton Keynes shopping centre is among the best. It was opened by Mrs Thatcher, the then Prime Minister, on 25 September 1979. In the early days there were real fears that it would be a white elephant, and it badly needed the commitment of one or two really prominent retailers. It is widely believed that Marks & Spencer would not commit until John Lewis did, and that John Lewis would not commit until Marks & Spencer did. In the end they both did and these two major magnets for shoppers are at opposite ends. It now seems inconceivable that they would not want to be there, but it was not obvious at the time.

The church of Christ the Cornerstone is an interesting and distinctive building. It was opened in 1992 and was the first purpose-built ecumenical city-centre church in the UK. It hosts five denominations: Baptist Union, Church of England, Methodist, Roman Catholic and United Reformed Churches. The church's website says, 'The church is open seven days a week for private prayer and public worship. Our building is a centre for the community of the whole city.'

Milton Keynes hosts the National Badminton Centre and is home to the Red Bull Formula 1 Team. There are ten golf courses within the city and surrounding areas. Greg Rutherford, who won the gold medal for the long jump at the 2012 Olympics, grew up and lives in Milton Keynes.

You cannot miss the Xscape building. It is large, with a distinctive sloping shape and is at a high point in Milton Keynes. It can be seen for miles around. There is a snow slope with real snow, so you can enjoy skiing and snowboarding. The complex also

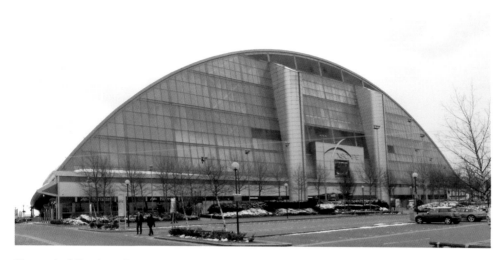

Xscape building in Milton Keynes.

includes a sixteen-screen cinema, bowling, rock climbing, shops and restaurants. Other attractions in Milton Keynes include a 1,400-seat theatre and The Stables which seats 398 and is one of the UK's leading live music venues. For the cerebral, there is a leading art gallery.

There has been quite a lot to digest, so let's end on a less serious note. The Fenny Poppers are six ceremonial cannons in Fenny Stratford that fire blanks. They were first fired in the 1740s and were recast in 1859. It has been reported that the noise has been heard from as far away as Olney. They are fired three times on St Martin's Day (11 November) and on special occasions. These have included the 100th birthday of the Queen Mother and the present Queen's Diamond Jubilee.

Milton Keynes divides opinion and you either like it or you don't. As will probably be apparent, I do like it.

Bradwell Abbey

Bradwell Abbey is on the left side and approximately halfway through the short distance from Milton Keynes Central to Wolverton. You should see a small and low chapel not far from a white house. It is in an open area, immediately before the train passes over a dual carriageway. At the time of writing the chapel is covered in protective cladding, but hopefully this will have been removed before the book is published. After Milton Keynes Central you will pass a go-kart track on the left side of the train. There is then about 1½ miles to go.

The Benedictine Priory was founded at Bradwell in the early to mid-1140s, so it was less than seventy-nine years after the successful invasion by William the Conqueror.

Bradwell was originally a cell of the Luffield Priory. I would not recommend looking for this because it is now under the Silverstone racetrack. After 1189 Bradwell became independent from Luffield. The date is apt because the term 'time immemorial' is taken to be any time before the accession of Richard I on 6 July 1189. Just a very few documents survive from the early days, but one of them, converted into modern language, deserves to be quoted:

> Mandate to the archdeacon of Buckingham to warn and if necessary excommunicate Simon of Wolverton a runaway monk of Bradwell, who has stolen goods from the Monastery, and all persons aiding and abetting him.

It seems that Simon had been a seriously naughty monk!

In the early fourteenth century the priory fell on hard times. There was a series of famines, followed by the devastating Black Death in 1348–50. Its prior was one of the many who died at this terrible time. Despite all these horrors the chapel was added to the west wall of the monastic church. This was done in the period 1330–50.

In 1524 Bradwell Abbey was dissolved on the authority of the Pope and then given to Cardinal Wolsey by Henry VIII. This was twelve years before the dissolution of the monasteries, which started in 1536. Dissolution was later accomplished by an order of suppression and the chapel was and is the only religious building at Bradwell left standing. No more than five monks were in residence at the time of the dissolution. It is quite a thought that what you see from the train is the part that was left more than 460 years ago.

Following the disgrace and death of Wolsey and after the dissolution, Bradwell passed to Sheen Priory in Sussex and then to the Crown. Its ownership changed hands several more times and finally it was bought by Milton Keynes Development Council in 1971. At this time the chapel was overgrown and it had been used as a farm building for more than 100 years.

The full importance of the site began to be realised in the 1960s, and it took a hole in the roof and dripping water to uncover what has been described as a national treasure. The water began to dissolve the whitewash, uncovering some really splendid medieval paintings. Conservation work started in 1967 and this continued in phases until 1984. It became apparent that the east wall of the chapel dated from the second half of the thirteenth century and was actually part of the destroyed monastic church. The foundations of the full church were discovered and they have been laid out in gravel. They can be seen during a visit.

In the Middle Ages it was normal for the interior of many churches and cathedrals to be covered with paintings. They would sometimes show biblical characters and scenes, sometimes be purely decorative and sometimes would be a combination of the two. The paintings would be made on the fabric of the building, not done separately and hung as is often the case today.

It is very unusual for these paintings to be available to us now, even when the buildings have survived, and this is what makes the chapel so important. Many of the paintings in other places were deliberately destroyed during the Reformation. The perpetrators

of this were opposed to imagery in places of worship. Fortunately at Bradwell the paintings were whitewashed, which did not destroy them. They lay undiscovered under the whitewash for around 400 years. Whitewashing was done in many churches and cathedrals, but there was another bout of destruction in the nineteenth century. The Victorians preferred exposed stonework, and in numerous restoration projects plaster and paintings were stripped away.

The chapel was dedicated to St Mary, hence the monogrammed Ms that can be seen on the interior walls. It is therefore not surprising that the predominant theme is scenes from the life of the Virgin Mary. A particularly fine example shows the Annunciation, which is the visitation of the Virgin Mary by the Angel Gabriel. Some of the paintings need interpreting, but are believed to include scenes depicting the Virgin's parents, Saints Anne and Joachim. Another is believed to show Mary visiting her cousin Elizabeth after she had been told by Gabriel that she would bear the son of God. Some pictures depict the Flagellation or Mocking of Christ. A particularly interesting one shows the Archangel St Michael weighing the souls of the dead to determine whether they will go to heaven or hell, the weight of the soul being influenced of course by deeds on earth.

The paintings are the jewels in the crown, but you should not have unrealistic expectations about their condition. They are medieval, were covered over for four centuries, and are part of a structure that was neglected and used as a farm building.

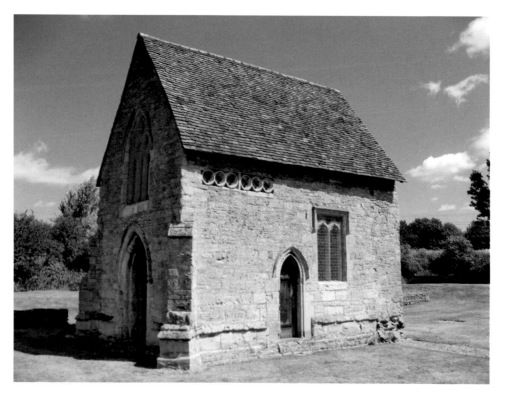

Bradwell Abbey. (Image courtesy of Milton Keynes City Discovery Centre)

Milton Keynes Discovery Centre is located at the site that includes the chapel. Its buildings include meeting rooms and it has archives about the history and development of Milton Keynes. It arranges tours and lectures about a range of subjects, but especially Milton Keynes. If you are considering a visit, you should be aware that the chapel is only open on certain special days. If entering the chapel is important to you, it is essential that you check this in advance. The telephone number of the City Discovery Centre is 01908 227229 and its website is www.mkcdc.org.uk.

The Concrete Cows

Muhammad Ali reckoned he was so quick that he could get out of bed, turn off the light and be back under the covers before it was dark. You will have to be nearly as quick if you want to see both Bradwell Abbey and the *Concrete Cows*. More realistically you will probably need to see one of them on a second journey. Bradwell Abbey is on the left-hand side immediately before a bridge over a dual carriageway. The *Concrete Cows* are on the right-hand side immediately after the bridge. You will need to look down into a grassy area. There are six cows and they are close to both the road and the track.

The cows are approximately halfway through the relatively short distance from Milton Keynes Central to Wolverton. If you are not looking for Bradwell Abbey, you will see, on the right-hand side of the train, some allotments, a sports field and then the *Concrete Cows*.

The *Concrete Cows* are a work of sculpture created in 1978 by Liz Leyh. In the early days of Milton Keynes she was artist in residence. There are three cows and three calves. She would, I think, have been astonished by their subsequent fame. Many

The *Concrete Cows* in Milton Keynes.

people associate them with Milton Keynes in the way that they associate the *Angel of the North* with Gateshead. The home supporters stand at MK Dons is known as the 'Cowshed' and the team mascots are two pantomime-style cows. A television programme made for Sky in 2005 named the *Concrete Cows* as one of the most influential works of twentieth-century open-air sculpture in England.

The original cows were moved from their open-air site to a position in the Milton Keynes shopping centre. They can be viewed there, but the replica replacements are more famous and these are the ones that you can see from the train. The replica cows are the responsibility of the Parks Trust. This is an independent charity that owns and looks after many parks and open spaces in Milton Keynes, and these include the field in Bancroft where they are located.

There is a long history of interference with the cows. Sometimes it has been funny, interesting or both, but sometimes it can only be described as graffiti or vandalism. Funny or not, it costs £2,000 to repaint the cows and the money comes from the funds of the charity. They have got other things to spend £2,000 on.

Over the years the cows have been placed in compromising positions, painted pink and been painted as zebras. They have acquired mad cow disease and had pyjama bottoms added. On one occasion a calf was kidnapped and ransom demands sent to local papers. They were painted as skeletons ahead of Halloween in 2012. The painting was very well done and liked by a lot of people. They will be restored to their proper colours, but they are still in their Halloween colours at the time of writing. The photograph shows them in this state.

I love the cows and I defy you not to do so. There is something appealing about them. If you are ever in the area, it is worth having a look. You will very probably come away smiling.

Wolverton Wall Mural

The mural is 173 yards long, and by some accounts it is the longest wall mural in Britain. However, I have no means of verifying this and there may be other candidates. It is a black design on a white background.

The mural is on a wall that runs along the canal towpath. It can be seen on the left side of the train about a mile beyond Bradwell Abbey and the *Concrete Cows*, and about a quarter of a mile before Wolverton station. The wall and the canal curve round and just under half of the mural can easily be seen. The rest of it can be glimpsed through trees and is therefore more visible in winter.

The mural is on the retaining wall of the old railway works and it represents Wolverton's past, present and future. Wolverton claims to be the world's first railway town, so it is not surprising that a depiction of a train runs the whole length of the mural. There is an engine at each end and a mixture of carriages and trucks in between. These portray different styles and ages of the rolling stock. The engine at the end that can readily be seen from the train carries the name 'Bill Billings'.

Various things can be seen on the trucks, over the trucks and in the background. I readily spotted aeroplanes, balloons, cranes, a tank, signals, an air ship, factories and factory chimneys, helicopters and a signal box. This is by no means an exhaustive list. I think that it is terrific, and so does my wife who looked at it with me.

The mural was created in 1986 by Bill Billings, the man whose name appears on the engine. It was done as part of the Milton Keynes Urban Aid Scheme and in association with the Milton Keynes branch of the Inland Waterways Association. Periodic repairs and restoration have been required and this was last done in spring 2011. The work was organised by the Milton Keynes branch of the Inland Waterways Association with help from Wolverton Council. Some of this work was done by offenders under the guidance of the Probation Service, and this was also the source of some of the workers in 1986.

This last repair was a really major one. All the remaining paint was taken off and repairs and restoration to the surface of the wall were carried out. The mural was then repainted to the original design. Bill Billings' son Ryan Billings was one of the artists who did this. Prior to this, the mural had acquired graffiti, but I am both surprised and delighted to report that it now appears to be graffiti free.

The wall is old. In parts it is not in a good condition, and there is only so much that can be done. As the wall deteriorates further it will become progressively more and more difficult to maintain. We must wish good fortune to those who, over the years, will do the work.

Wolverton Wall Mural.

Bill Billings was a much respected man. I sometimes think that a funeral can be a good indicator of this and it is reported that 500 attended Newport Pagnell church for his. He died suddenly on Boxing Day 2007 at the age of sixty-nine. He had been for many years a member of the SAS, a fact which he did not publicise. Many of the mourners discovered it by seeing his beret and medals on the coffin. Bill was known as a popular, people's artist. He was highly regarded for his street work and was a self-styled poet, playwright, sculptor and musician. Another notable example of his work is the huge concrete dinosaur at Peartree Bridge in Milton Keynes. He was awarded the MBE in 2000, but it reputedly did not curb his battles with authority to further his community art aims. He left quite a legacy.

Wolverton:
The World's First Railway Town

Wolverton station is 4 miles from Milton Keynes Central station and a quarter of a mile beyond the wall mural. Between the mural and the station, the train passes over the Grand Union Canal. The bridge is made from numerous cast-iron girders and is not attractive, but it dates from 1838 and is a Grade II listed monument. One of the old railway buildings can be seen on the left side of the train. It is about 100 yards from the line and can be seen from the latter part of the station and beyond.

Wolverton was the world's first 'railway town'. It is positioned roughly halfway between London and Birmingham, and this was the main reason why the London & Birmingham Railway chose it to be the location of the locomotive repair shop. The decision was made in 1836 and operations started in 1838 when the line was opened. Initially the locomotives were purchased, but after a few years manufacturing began side by side with repairs and servicing. In 1846 the London & Birmingham became part of the London & North Western Railway, and it was subsequently decided that locomotives would be built and repaired at Crewe. When manufacturing stopped, a total of 166 locomotives had been built at Wolverton, which instead became the largest carriage works in the country. Wagon-building was introduced in 1923 and continued until 1962.

At its peak the railway works covered 80 acres, which is about the area of fifty-five average-sized football pitches. A notable feature was a rather unattractive 10-foot-high, quarter-mile-long wall. This ran from the station to the western end of the works.

A lot of workers were needed. In 1831 the population of Old Wolverton was just 417. In 1841, three years after the railway was opened, 1,261 lived in the new Wolverton. In 1891 it was 4,147, and by that time nearby New Bradwell had been established as a second railway town. Workers also came in from Stony Stratford, Newport Pagnell and various villages. A workforce of 2,000 was employed at the works by 1860 and the number continued to expand. By 1962 the works employed around 5,000 people, but this was the peak, and employment declined sharply afterwards.

For thirty-eight years from 1887, workers were brought in from Stony Stratford by the Wolverton and Stony Stratford steam tram. At 44 feet long it was the largest steam-powered tram ever to run in Britain and possibly the world. Its staff joined the General Strike in 1926 and services were not resumed afterwards.

For well over a century Wolverton was what we would recognise as a company town. These were unusual in the south, but in some ways it was similar to mining villages or the mill towns of Lancashire. The company was paternalistic and a generally benevolent employer. By 1844 the railway had built 200 houses and more followed later. Many of the streets in Wolverton were named after the directors and senior managers of the company. The houses were rented, but much later, in some circumstances, the tenants were allowed to buy them. The company also built schools and a church. The schools were reportedly good and educated girls as well as boys. They provided a stream of suitable apprentices for the railway works.

The building of the new church was, partly at least, inspired by the unpopularity of the local parson. He did not like railway workers and his services were very badly attended. Perhaps the fact that he was a magistrate had something to do with it. Some of the cases that he tried involved railway workers caught poaching. The company financed a new church and influenced the selection of its first minister. It was a good choice and the appointed man was able to develop a very good relationship with his flock.

The railway company was certainly a caring employer, but there was a notable instance of the directors not acting in this fashion. After the collapse of the General Strike in 1926, the directors posted notices stating that they would not commit to taking back all the strikers. As a result the strike partially continued in Wolverton. After a while, and under government pressure, the company relented, but much bitterness remained.

The expansion of the railway works required both the line and the station to be repositioned. The original line through Wolverton was straight, but the line and station were moved eastwards in 1881. This resulted in a tight curve, which you may well notice as you pass through. This has caused problems and the Advanced Passenger Train of the 1970s and early 1980s failed its test here. However, it has not been a problem for the modern Pendolino tilting trains.

The very early engines could not go much more than 50 miles without attention, so for some time all the trains had a 10-minute stop at Wolverton while the engines were changed. In this they were similar to Brunel's London to Bristol Great Western, which had a 10-minute stop at Swindon. It was just as well there was a break because the passengers would have been ready for it. At the beginning the journey time from London to Wolverton was three hours. In the very early days, travelling was done in great discomfort. There was neither heating nor lighting. Second-class coaches were open at the sides and had holes in the floor to let out water. Third-class travellers were in roofless and seatless trucks, with up to sixty in each one. It was therefore not surprising that when a train pulled in at Wolverton there was a rush for the toilets and the refreshments. Wolverton looked after its passengers very well, and in this it was unlike Swindon where the Great Western had given a long-term contract to an

outside caterer. Its shoddy service regularly drove Brunel to distraction. Wolverton was superb for its time and there was even a sunken icehouse, so that ice could be served throughout the year.

Sir Francis Bond Head reported in 1850 that the refreshment establishment was composed of a matron, seven very young ladies to wait upon the passengers, four men and three boys, a man-cook and his kitchen maid, two scullery maids, two housemaids, one still-room maid whose sole job was to make tea and coffee, two laundry maids, one baker's boy, one garden boy and an odd-job man.

The seven very young ladies were awakened at 7.00 in order to be ready for the first train at 7.30. They were superb at their job, which was to serve a large number of people efficiently in a very short time. The excellent matron said that no breath of slander had ever sullied the reputation of those committed to her charge. Sir Francis also reported that four of the seven young ladies had made very advantageous marriages and were well off in the world. Perhaps despite their frantic activity they managed to give extra attention to the first-class travellers.

Wolverton has a long association with the royal train. In 1869 it provided Queen Victoria's Saloon, which is now in the National Rail Museum in York. Further royal coaches were provided for Edward VII in 1903 and Elizabeth II in 1961. The most recent royal train was fitted out in Wolverton in 1977, and it is still based there. First of

Wolverton station.

all it was in the care of Railcare, then EWS. It is now looked after by D. B. Schenker. I am told that, for obvious reasons, security is very tight.

The glory days have departed and railway employment at Wolverton has nearly gone, though Railcare is a successful rolling stock services provider and employs around 250 at Wolverton. Nevertheless, Wolverton is no longer a railway town and a significant part of the railway works is now a Tesco supermarket. In a nod to the site's heritage, the frontage has been made to resemble the original buildings. Other parts have been and are being developed for housing and other use. Some of this is within the shell of the old buildings.

One thing that is still there is the camaraderie of the people. It is a tightly-knit community. Many of the residents once worked for the railway or come from families that did. There are two thriving working men's clubs and people meet to drink and talk together. It will not last forever, apart from anything else because of the newcomers to the town, but it is there now.

Before leaving Wolverton it is worth considering the effect of the railway on established businesses. Nearby Stony Stratford was well-known as a staging post for stagecoaches. Two staging inns were The Cock and The Bull, and there was a tradition of telling tall stories in them. This is the origin of the saying 'a cock and bull story'. In Stony Stratford the number of stage coaches dropped from 280 a week in 1835 to 12 a week in 1844. The small town had to make a lot of changes. There are many parallels in our own time. Retailers that have not adapted to the internet age have often not prospered.

Hanslope:
Parish Church of St James the Great

The church is on the right side and is 1¼ miles from the track at the nearest point. The spire can be seen from about 2 miles beyond Wolverton and then on and off for a considerable distance, both from the direct line to Rugby and also from the Northampton Loop.

It is a beautiful church in an attractive village, and it is a church seen every day by many people. This is because the spire is so high and because it is seen across low-lying countryside. As well as from the railway, the spire can be seen for miles from the M1 motorway and the Grand Union Canal. It can even be seen as far away as the Dunstable Downs.

The spire was built early in the fifteenth century and it was originally 206 feet high. It collapsed in 1804 when struck by lightning and was rebuilt to its present height of 186 feet. This is 5 feet less than All Saints parish church in Leighton Buzzard, but it is still the highest church spire in Buckinghamshire. There are forty-nine narrow spiral steps leading to a parapet round the base of the spire. The tower is open on the church open days. These are the weekend nearest to St James's Day, which is 25 July.

There is a ringing chamber part way up the staircase and it is here where the first of two tragedies in and around the church took place. In 1867 a young man was killed while bell ringing. The bell turned over and carried him aloft where his head struck a beam. Sadly he did not regain consciousness and died a few hours later.

After my visit I wrote down the three words that were in my mind. One was peaceful and the other two were well-kept. There is a large well-kept graveyard and it is a large church, being 136 feet long and 61 feet wide. As with so many churches, one marvels at how, at one time at least, the size of the church was appropriate to the size of the community. It is of course big inside as well as big outside, and it is still not a large village. In 1862, 500 women and children in the area were employed making pillow lace. Perhaps they came to services, but the church was complete long before then.

The church is a Norman building and was established on its present site in 1160. There is much of interest to note, but a good place to start is that some of the chancel dates from then, and that there is a chapel that was built at the end of the thirteenth century. Until recently it was used as a vestry. A priest's doorway dates from the twelfth century, though of course the door does not.

The second tragedy was the shocking murder of Squire Edward Hanslope Watts and the suicide of his murderer William Farrel. The sixty-seven-year-old squire was

The parish church of St James the Great in Hanslope

a respected and powerful man, whose family had lived in the nearby Hanslope Park House for generations.

On Sunday 21 July 1912, Watts and his wife attended morning service at the church. They had almost reached home afterwards when Watts was hit by a blast from a shotgun. As he fell to the ground his wife, who had been walking a few paces behind, rushed to comfort him, and as she did so Watts was hit by a second shotgun blast. It is not known whether the second blast was aimed at Mrs Watts or her husband, but Watts was dead, almost certainly killed by the first blast.

A short time later another shot was heard from a nearby wood. The body of Farrel was found with a shotgun lying on his body. He had committed suicide by shooting himself in the mouth. Farrel was the Squire's head gamekeeper and he had recently been given two weeks' notice by Watts. This would mean leaving the cottage where he lived with his wife Annie and their three young daughters. After the tragedy there was a lot of sympathy for Annie Farrel, and indeed she was given financial assistance.

It had to be decided whether or not Farrel could be buried in hallowed ground. The Bishop of Oxford and the vicar of Hanslope took the compassionate view, and he was buried in the churchyard at night, just four days after the murder and suicide.

There was a further twist to the story. Annie Farrel later had a gravestone erected and it included the phrase 'waiting till all shall be revealed'. What does this mean? Nobody knows, but it greatly offended the villagers. Local opinion moved sharply against Annie Farrel, who later went to live near her family in Lancashire. There were threats to smash the gravestone and the police mounted a 24-hour guard on it until tempers had cooled.

Bridge HNR/200 and Why it is There

Bridge HNR/200 is 7 miles north of Wolverton, and shortly before Roade where the Northampton Loop moves off to the right. It crosses the Ashton to Hartwell Road. There is nothing special about the bridge, but it is as good a place as any to consider why the line takes this particular route. That really is interesting.

Had the original plan been implemented, the line would have taken a route about 10 miles to the west of Bridge HNR/200. Furthermore, Buckingham rather than Wolverton would have been the world's first railway town. The fact that this did not happen was due to the pig-headedness, lack of imagination and political connections of a string of landowners, foremost among them being the Duke of Buckingham.

On 4 July 1831 the secretary of the fledgling London & Birmingham Railway Company wrote that he favoured the line passing through the Chiltern Hills at Tring. It should then proceed to a point north of Aylesbury, then to Whitchurch, Winslow, Buckingham, Brackley and on to Birmingham. To use a phrase that probably was not in vogue at the time, all hell broke loose. Many landowners did not want the noise and smoke that they thought the railway would bring.

The most powerful adversary was Richard Temple Nugent Brydges Chandos Grenville, First Duke of Buckingham and Chandos, who came from a powerful political family that had provided three Prime Ministers. The favourite of his several houses was Stowe, situated just to the west of Buckingham, and he also owned a lot of nearby land. He was determined that the railway would go nowhere near Buckingham.

The duke's political influence was massive, but he used other methods too. J. K. Fowler wrote in *Echoes of Old Country Life* that 'he raised a complete *posse comitatus* of his labourers and dependants to oppose the survey'. You may not be surprised to learn that I was not immediately familiar with the phrase *posse comitatus* and had to look it up. It is the common law right of a law enforcement officer to conscript any able-bodied males to assist him. Fowler went on to say 'there was many a fight and breaking of heads, and every obstacle was raised to prevent a survey being made and the levels taken'.

Robert Stephenson was commissioned to write a second report and with a few adjustments this was adopted. Like the previous proposal it passed through the Chiltern Hills at Tring, but then went via Leighton Buzzard, Wolverton and Rugby. There was dissension south of Tring as well as north of it and turbulent public meetings were held. Some powerful people managed to get adjustments made. One such was Sir Astley Cooper who succeeded in getting protection for his land. This is why Hemel Hempstead station is at Boxmoor, 1 mile from Hemel Hempstead.

Bridge HNR/200.

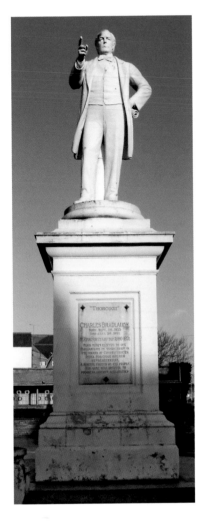

Charles Bradlaugh's statue in
Abington Square, Northampton.

The 1st Duke of Buckingham was noted for gluttony and financial irresponsibility, as well as his hatred of railways. He died in 1839, leaving the estate virtually bankrupt. His son did not share his father's views on trains, and with Sir Harry Verney was instrumental in bringing a railway through Buckingham. This was the Buckinghamshire Railway that connected Banbury with Bletchley. He was not as bad as the 1st Duke, but was financially irresponsible too, and in particular he spent a fortune entertaining royalty. He went bankrupt and fled to the continent in 1847. Stowe and its contents were sold.

The 3rd Duke was by far the best of the three. Despite the family disgrace he had a distinguished career, including being chairman of the London and North Western Railway from 1853 to 1861. This incorporated the London & Birmingham Railway that his grandfather had fought so hard to keep away from Buckingham. While he was chairman he turned down the offer of a cabinet position. He resigned to take up the position of Governor of Madras.

The Northampton Loop I: Northampton

Northampton is a major town with a population in excess of 200,000. It is located on the Northampton Loop, which leaves the main line after Wolverton at Roade and rejoins it shortly before Rugby. There is a tunnel on the approach to Northampton and then the Lift Tower is an indicator that you are almost there. This can be seen on the left side of the train and is near the station.

Like Milton Keynes, Northampton is not a city – in both cases applications for city status did not succeed. Located on the River Nene (which periodically floods), it is in fact the most populous district in England that is not a Unitary Authority. Unlike Milton Keynes, which has a short and interesting history, Northampton's history is long and interesting.

Early settlements date back to the sixth century and King Richard I (the Lionheart) granted the town its first charter in 1189. It had a castle, built soon after 1084, and Thomas à Becket was tried there in 1164. The town supported Parliament in the Civil War, and as a punishment Charles II later ordered the castle and town walls to be torn down. The remains of the castle and its foundations were destroyed when the railway came to Northampton in 1879 and Castle station was built on the site. If you refer back to the section on Berkhamsted Castle, you will be reminded that this was the second castle diminished or destroyed by the railway. Progress comes at a price.

There have been two major battles at Northampton. In 1264, supporters of Henry III defeated supporters of Simon de Montfort, and in 1460 there was a decisive battle in the Wars of the Roses. Henry VI was captured by the Yorkists in the town. A less violent event was the Treaty of Northampton, which was signed in 1328. This was a peace treaty between the English and the Scots and it recognised the authority of Robert Bruce as King of Scotland. It also betrothed Bruce's infant son to Edward III's sister Joanna. Edward was only fifteen at the time and poor Joanna, who was only four, did not have any say in the matter. Her future husband was aged six.

Northampton is, or at least was, renowned as a centre of shoemaking and other leather industries. Sadly most of this has now gone. The small part that remains includes Church's, which has been making shoes in Northampton since 1873, and Trickers, which has been there since 1829. In all that time, Trickers has been and still is under the control of the Barltrop family. Many of the old shoe factories remain, mostly converted for office or residential use. Some of them are surrounded by terrace houses built for the factory workers. In place of the shoe factories, the town now mainly provides employment in finance and distribution. Carlsberg has a major presence. Its brewery, which was opened in 1974, was the company's first outside Denmark. It is welcome in Northampton, but it does sometimes cause a smell to hang over the town.

I have felt an affinity with Northampton since my teenage years, a state of affairs that many people find puzzling. It started with a chance sighting of Charles Bradlaugh's statue in Abington Square. I afterwards researched his story and found it fascinating. It is, I think, worth telling in this book.

Born in 1833, Bradlaugh became an atheist in his teens and in 1866 was a co-founder of the National Secular Society. He edited a secularist newspaper entitled *The National*

Reformer and in 1868 was prosecuted for blasphemy and sedition. The prosecution failed and he was acquitted. In 1876 he published an American pamphlet advocating birth control. Its previous publisher had already been successfully prosecuted for obscenity. Bradlaugh was fined and sentenced to six months' imprisonment, but the conviction was overturned on a legal technicality. He was a republican and an advocate of trade unionism, women's suffrage and Irish home rule. Bradlaugh was a brilliant speaker and campaigner, very popular in some quarters and, as can be imagined, hated in others.

He was elected the Liberal Member of Parliament for Northampton in the 1880 general election. He presented himself at Westminster and politely requested to affirm rather than take the required Christian oath. Permission was not given and he was unable to take his seat. Bradlaugh then wrote an open letter to *The Times* in which he offered to take the oath, but his letter included the words 'regard myself as bound not by the letter of its words but by the spirit which the affirmation would have conveyed had I been permitted to use it'. Many Honourable Members took offence at this and he was again refused permission to take the oath. On a further occasion he offered to take the oath and said that he would regard it as binding on his conscience. Permission was not given and he was ordered to withdraw from the House. He refused and was taken into custody. A by-election was then called for the Northampton constituency. Bradlaugh won and he also won the three further by-elections that followed. He thus acquired the distinction of being elected five times for the same seat during the course of a single Parliament. Amid all this nonsense he was escorted from the House by police officers and in 1883 he somehow managed to participate in three votes. For this he was fined £1,500. A bill allowing him to affirm was defeated in Parliament.

Honourable Members finally saw sense and he was allowed to take his seat in 1886. In 1888 he secured passage of the Oaths Act, which regularised his position and that of Non-Christians who followed. It helped not only atheists but Jews and others. Bradlaugh was by common consent an effective MP in the short time available to him. He died in 1891 at the early age of fifty-seven. His statue in Abington Square is a fitting tribute.

The Guildhall, in St Giles' Square, is a splendid statement of civic pride of a type more commonly found in the north than the south. It was built in neo-Gothic style between 1861 and 1864, and sympathetically extended between 1889 and 1892. There was a further extension in 1992. As well as housing Northampton Borough Council, the Guildhall is used for the conducting of weddings and civil partnership ceremonies, and for a variety of civic purposes. There is an impressive Great Hall, with walls decorated to represent famous people associated with the town, and also murals of *The Muses Contemplating Northampton*. The lobby of the east extension contains a statue of Spencer Perceval. He was a Member of Parliament for Northampton and is the only British Prime Minister to have been assassinated. There is also a memorial to Diana, Princess of Wales. She grew up in nearby Althorp and was made a Freeman of the Borough of Northampton in 1989.

The three prominent sports in Northampton are football, cricket and rugby, but the greatest of these is rugby. Northampton Saints were formed in 1880. They were

successful from the early days and they have always played their home games at Franklin's Gardens. This has a capacity of 13,591 and they almost always achieve crowds at or near this number. They play in the Premiership and at the time of writing are mid-table. The most revered player is probably Edgar Mobbs, who captained England and played for the club before the First World War. On the outbreak of war he tried to enlist but was rejected because he was too old. He responded by raising his own battalion. Mobbs was killed on 29 July 1917. He led his battalion over the top by kicking a rugby ball into no man's land and then following it out. The Mobbs Memorial Match is played every year.

Northampton Town Football Club plays at Sixfields. The club has for many years played in the lower reaches of the Football League, and at the time of writing it is challenging for promotion from League Two, which is the fourth tier of English football. Northampton enjoyed a short-lived blaze of glory in the 1960s. After a remarkable three promotions in five years, the club played in Division One (which was then the top division) in the 1965/66 season. Then three relegations saw it back in Division Four for the 1969/70 campaign.

Northamptonshire County Cricket Club has played in the County Championship since 1905. It has never won it but has been runner-up on four occasions, the last time being in 1976. In recent years its fortunes have been mixed and it currently plays in the second division. It once endured a record-breaking dreadful run. It only finished above second from last four times between 1923 and 1948. This included a period in which the team had no fewer than ninety-nine games without a single win – running from May 1935 to May 1939. Over the years some famous players have represented the county. The most memorable was Frank Tyson, who was probably England's fastest bowler ever. Unusually for professional cricketers of the time, he was a university graduate and a school teacher. Rather than sledging batsmen he would, in a literate way, quote Shakespeare or Wordsworth to them.

Northampton has the honour of hosting one of the three remaining Eleanor Crosses. The story of Queen Eleanor and the crosses is a fascinating one and worth a place in this book. Edward I married Eleanor of Castile in 1254. She was thirteen at the time and Edward was a year older. It was a politically arranged marriage, but it developed into a love match. They were a devoted couple and Eleanor bore fourteen children. Eleanor died at Harby in Nottinghamshire in 1290. Her viscerea (large internal organs) were buried in Lincoln Cathedral and the rest of her body was transported to London. Her heart was buried in the abbey church at Blackfriars, and her body was buried in Westminster Abbey at the feet of her father-in-law, King Henry III. A grieving Edward ordered that elaborate stone monuments be erected at the twelve places where her body had rested on its journey to London: Lincoln, Grantham, Stamford, Geddington, Northampton, Stony Stratford, Woburn, Dunstable, St Albans, Waltham Cross, Cheapside and Charing Cross. The only ones remaining are at Geddington, Northampton and Waltham Cross, so the Northampton Eleanor Cross is rare and of historical significance. It stands at the edge of Delapré Abbey. The cross is octagonal and set upon stone steps. The present steps are replacements. It is built in three tiers, the bottom tier featuring

open books. The statues on the cross were carved by William of Ireland and he was paid £3 6s 8d for each one.

The Northampton Loop II: Althorp

Althorp is about 5 miles beyond Northampton and on the left of the train. It is about 2 miles beyond a golf course and about three quarters of a mile after the train emerges from a short cutting. The black iron gates to the walled park lead on to a road and are about half a mile from the train.

Althorp will forever be associated with Diana, Princess of Wales. She was a Spencer and nineteen generations of the Spencer family have lived at Althorp. Much of her childhood was spent at Park House on the Sandringham estate in Norfolk, but she frequently visited Althorp to see her grandmother and grandfather, the 7th Earl Spencer. Diana was nearly fourteen and at boarding school when her grandfather died and her father became the 8th Earl. He promptly moved his family to Althorp.

You will probably remember the extraordinary grief that gripped the country following Diana's death in 1997 and the tribute at her funeral delivered by her younger brother. This was Charles who had become the 9th Earl Spencer on the death of his father in 1992. Diana's funeral cortége passed through the gates that can be seen from the train and she is buried on a small island in the Round Oval Lake, which is in the park.

The walled park covers 550 acres and is set in glorious countryside that is both tranquil and beautiful. The whole estate covers 14,000 acres, and as well as the house it encompasses a stable block and cottages.

Althorp has been owned by the Spencer family since 1508. The house was built by Robert Spencer, 2nd Earl of Sunderland, in 1688, but the architect Henry Holland was commissioned to make extensive changes starting in 1788. Splendid old houses have a habit of needing restorative work and money spent on them. A major restoration project is currently underway. As you might expect the house contains some wonderful pictures, porcelain, furniture, etc. In recent years some of the contents have been sold, probably to fund the restoration work, but a lot remain.

Each year Althorp is open to the public from 1 July, which was Diana's birthday, until approximately the end of August, though it may be closed for odd days in this period. Details may be obtained from www.althorp.com. A visit may include free access to an exhibition depicting the life and work of Diana, Princess of Wales. All profits go to the Memorial Fund set up in her memory.

Althorp is a licensed venue for civil weddings and civil partnership ceremonies, and its facilities may be hired for a variety of purposes. A renowned three-day literary festival is held each June.

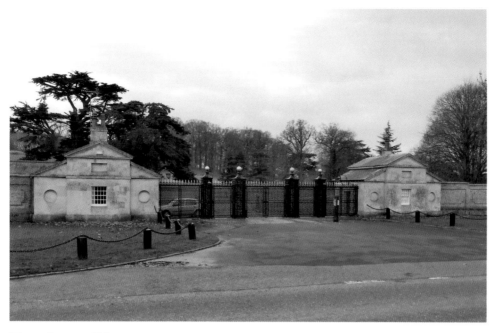

The park gates, Althorp.

Northampton Lift Tower

As the name implies, the lift tower is in Northampton, which is on the right side of the main line. At the nearest point it is 6½ miles away, but due to its height it can be seen for some time. It is close to Northampton station and can be seen extremely well on the left side from a train using the Northampton Loop.

It was formerly the Express Lift Tower, but is now the National Lift Tower. Terry Wogan once dubbed it the Northampton Lighthouse, and quite a few people refer to it by this name. It is a lift-testing tower, built by the Express Lift Company and opened by the Queen on 12 November 1982.

Express Lift was taken over by Otis in 1997 and the tower was subsequently closed. In the same year, the tower was made a Grade II listed building, the youngest structure to be accorded this status. The tower and surrounding land were sold for housing in 1999 and the tower is now rather incongruously sited in the middle of a housing development.

The lift tower was reopened in October 2009 and it is once again used by lift companies for research, testing and marketing. It has other uses too and has, for example, been used for testing working at height safety devices. There are six shafts of varying heights and speeds.

The tower is 418 feet high and the upper part has a distinctive pierced, jagged shape. This is to reduce the vortex effect. It is the only structure of its kind in the UK.

The great height has been utilised for other than business purposes, one of them being to raise money for charity. Abseilers have used it in this way. As part of the

Northampton
Lift Tower.

Cultural Olympiad, it was the focus of a laser show in the period leading up to the 2012 Olympics, and there was a splendid light show on 30 November 2012 to mark the tower's thirtieth anniversary. The tower was bathed in red, white and blue, the colours of the Union Jack.

Weedon Bec

Weedon Bec is a village approximately 17 miles beyond Wolverton. Watling Street passes through it and its name is frequently shortened to just Weedon. When the train emerges from Stowe Hill Tunnel a white public house named the Narrow Boat can be seen on the right. Weedon Bec is a further three quarters of a mile and is approached on an embankment. The line bisects the village at a fairly high level and the Grand Union Canal is immediately on the right, also at a high level. There would be an awful flood if the bank of the canal were to be breached at this point. On the left side there is a very brief glimpse of a corner of the ordnance depot. This is from a bridge and the approach to it.

The ordnance depot, barracks and three large pavilions were constructed in 1803 during the Napoleonic Wars. The depot, which was later extended, was a central small arms depot for the British Army. It was served by a branch of the Grand Junction Canal, which had reached Weedon in 1796, and it was later served by a branch of the railway. The barracks held a standing battalion, a troop of cavalry and a troop of horse artillery. The barracks and the three pavilions were demolished in the 1950s.

The ordnance depot at Weedon Bec.

When the buildings were erected the country was in an alarmed state about a possible French invasion. Lord Nelson had not yet defeated the combined French and Spanish fleets at Trafalgar, making this prospect very unlikely. It is widely believed that had an invasion occurred and made progress, King George III and his family would have moved from London to Weedon.

It is a good story often told as fact, and it could be true, but there is no evidence to support it. On the other hand the pavilions were of a very high standard. If not fit for a king, they were superior to the normal accommodation of their projected military occupants. Furthermore, the canal would have provided excellent communications (by the standards of the time) for His Majesty. Is the story true? I suspect not, but many people disagree with me.

There are two further things that you might like to know. The first is that Radar was demonstrated from radio waves from the Borough Hill transmitter on 26 February 1935. This was from just outside Weedon. The historic event is commemorated by a memorial located off the A5, just south of Weedon on the Litchborough Road.

Sadly, the second thing to report is two serious rail crashes nearby. In 1915 a coupling on a Birmingham to Euston express detached and struck a sleeper on the up line. This pushed the track out of alignment just as the Euston to Holyhead Irish mail train approached. This had fifteen carriages and was hauled by two locomotives. The entire train derailed and part of it fell down the embankment. Ten people were killed and twenty-one injured.

The second accident was in 1951 and it occurred less than a mile away. A Liverpool to Euston express derailed, killing fifteen people and injuring a further thirty-five. The driver and fireman survived, and despite suffering from shock they managed to protect their train. An enquiry determined that there had been no fault with the track and that the train had not been travelling at an excessive speed. The cause of the crash was an excessively tight bogie axlebox on the locomotive.

Watford Gap Service Station

You have probably driven past Watford Gap service station on the M1 many times, and you may have visited it a number of times. You should therefore be familiar with it and its appearance from the front. However, unless you have looked out of the train at the appropriate moment, you will not know what the back looks like. The rear of the service station on the northbound side of the M1 is what can be seen on the right of the train. It is about 150 yards from the track to the motorway and the service station and car park are in between. The service station is about 8 miles from Weedon Bec and at the end of the stretch where the line runs right next to the motorway. The train is on an embankment when it passes very close to the back of it.

Three questions are frequently asked about the Watford Gap:

Watford Gap service station on the M1 Motorway.

It is not at Watford, so why is it so named?

It is at Watford, but not the large Hertfordshire town that we know and love. It is close to the small village of Watford in Northamptonshire. It causes no end of problems. You can imagine the confusion of a foreign visitor planning to drive down the motorway and meet friends in Watford.

What is it a gap between?

Watford Gap is a minor gap between two small hills, and it lies on a long-established route between the Midlands and South East England. Within a quarter-mile space can be found the A5 Road (Watling Street), the West Coast Railway, the M1 motorway and the Grand Union Canal.

Why is it said to be the dividing line between the north and south of the country?

The answer to the third question is lost in the mists of time. Apart from other considerations, it is nowhere near the north/south midpoint. If anything it might

claim to be the east/west midpoint. A tributary of the River Nene rises at Watford and flows eastwards. To use the popular phrase, it comes out in the Wash. A tributary of the River Leam rises at nearby Kilsby, flows westwards and comes out in the Bristol Channel. Be that as it may, Watford Gap is frequently said to be the dividing point, and reference to folk on the other side is often derogatory. People living in the south say that north of the 'Gap' they wear flat caps, breed ferrets and keep coal in the bath – those that have baths that is. Northerners say that south of the 'Gap' they are not friendly, cannot hold their drink and all talk with a plum in their mouth.

Watford Gap services opened on 2 November 1959 and was Britain's first motorway service station. The M1 opened on the same day, and originally ran from what is now Junction 5 to what is now Junction 18, though it has of course since been extended at both ends. The motorway was different in those days. Early photographs invariably show very few vehicles on it. There was no speed limit and no central barrier. There were horrific smashes when vehicles, especially lorries, crossed the central reservation and hit oncoming traffic.

The service station was owned and run by Blue Boar Ltd. This was because this family-owned company had a petrol station on the nearby A5 road and it petitioned the government that its business would be badly affected. Blue Boar was also offered the franchise for Newport Pagnell, which was the second service station. It declined because a second one would have over-extended it. In the event Newport Pagnell was taken by Forte. The original plan was that Watford Gap would be for lorries only and Newport Pagnell would be for cars only. The logic of this crazy idea escapes me, but it was abandoned before they were opened. Both service stations catered for all traffic. This was not the only fault in the planning. The government also believed that the service stations would be little used.

The facilities were not ready when the service station opened, so initially it operated from temporary buildings. The restaurant commenced business in 1960 and to start with it had a waitress service. There were even hostesses to greet diners and show them to their tables. Unfortunately, the customers were not willing to pay enough to justify this, so the restaurant quickly became self-service. In the opinion of many the quality of the catering rapidly declined to an unacceptable level, and in fact for many years it was regarded as something of a scandal. Needless to say Blue Boar did not see it that way and it is generally accepted that, in time, there was an enormous improvement.

In the early days Watford Gap Services was widely used by musicians going to and returning from performances, and sometimes they would arrange to meet up there. Ones that did included Cliff Richard, Dusty Springfield, The Beatles, The Rolling Stones and Gerry and the Pacemakers. Jimi Hendrix heard his contemporaries talk about Watford Gap so often that he thought they were talking about a London nightclub.

The fiftieth anniversary was celebrated in 2009, and as part of the jollifications cups of tea were sold at the 1959 price of 6p (1s 3d in pre-decimal money). It was obviously a bargain in 2009, but it strikes me that tea was expensive fifty years earlier. For that

I would have wanted a bone china tea set, finest Darjeeling and unlimited refills. Perhaps that is what I would have got. At an auction, Roadchef paid £1,000 for a book containing autographs of people who had visited in the '70s and '80s. It had been put together by a person working there at the time.

Kilsby Tunnel

Kilsby Tunnel is about 9 miles beyond Weedon Bec and shortly after Watford Gap Services.

The tunnel passes through Kilsby ridge and is 1 mile 672 yards long (1.381 miles). If you are interested and if you have nothing better to do, you can use this information to calculate your speed as you pass through. You just need to record the time it takes then do the calculation. If, for example, the time taken is 60 seconds, and as there are 3,600 seconds in an hour, the speed is 82.9 mph. The calculation is 1.381 × (3,600 ÷ 60) = 82.9.

Kilsby Tunnel is now the eighteenth longest on Britain's railway system, but when it was built it was by far the longest. Terrible and unexpected difficulties were encountered and overcome, but even without these it would have been a major achievement. It took four years to build and cost around £300,000, which was three times the anticipated expenditure.

The tunnel was double-track bore and work commenced in 1834. The last of approximately 30 million bricks was placed on 21 June 1838 and the first goods train passed through three days later. Passenger services commenced on 17 September 1838 and trains then ran all the way from London to Birmingham.

There were fears, especially among prospective passengers, that running steam trains through such a long tunnel might cause asphyxiation. Stephenson therefore incorporated two enormous ventilation shafts and a system of smaller shafts. The two big ones each have a diameter of 60 feet and stand impressively above the ground like Martello towers. One can be seen from the M45 motorway close to the junction with the M1, and the other can be seen from the A5. This is the one that is pictured in this book.

The terrible difficulty was waterlogged quicksand – a lot of it – and a lot of water. This had been a problem at the nearby Braunston tunnel, so Stephenson knew that it was a possibility. However, test bores had narrowly missed it. Nevertheless, it was there, as became apparent at an early stage. The roof collapsed, water flooded in and several men had a very narrow escape from drowning. The quicksand was about 120 feet from the surface and under a 40-foot thick bed of clay.

Stephenson considered abandoning the tunnel, but decided that it was possible to pump out the water. To this end a number of further shafts were dug, and water was pumped out at the continuous rate of 1,800 gallons per minute. Understandably the directors of the railway company were very nervous, and after thirteen months of pumping they told Stephenson that if it had not concluded after a further six months it

One of the Kilsby Tunnel ventilation shafts as seen from a point near the A5 road.

would be stopped and the tunnel abandoned. He pressed on and his confidence proved to be justified. Shortly before the six months were up the water stopped flowing and it became possible to complete the work.

The tunnel was built by 1,250 workmen using 200 horses. As can be imagined such an influx caused local problems. It is reported that every barn and outhouse in the village was occupied by navvies, and that those who still remained had to build themselves makeshift turf-covered shanties in the fields. F. B. Head writing in 1849 recorded

Besides the 1,250 labourers employed in the construction of the tunnel, a proportionate number of sutlers and victuallers of all descriptions concentrated on the village of Kilsby. In several houses there lodged in each room 16 navvies; and as there were four beds in each apartment, two navvies were constantly in each, the two squads of eight men alternately changing places with each other, in their beds as in their work.

My dictionary says that a sutler is a merchant who accompanied an army in order to sell provisions to the soldiers. There was regular trouble between the navvies and the local population and on one occasion the military was called in.

To put it mildly, health and safety standards were not what they are today. Kilsby Tunnel was a magnificent achievement, but as well as the financial expense it came at the cost of twenty-nine lives. Three of the fatalities were the result of ridiculously foolhardy behaviour. Three navvies dared each other to jump over one of the shafts. They jumped together and they fell to their deaths together.

Rugby and the Nineteenth-Century Railway Races

Rugby is 5 miles beyond the Kilsby Tunnel and 2 miles beyond the point at which the Northampton Loop rejoins the main line. It is of course famous for Rugby School, where Dr Thomas Arnold was the famous headmaster from 1828 to 1841. The school is the setting for Thomas Hughes' Book *Tom Brown's School Days*, which was published in 1857 and has never been out of print. The sport of rugby was developed at the school and, so it is said, had its origins during a game in 1823 when, in clear contravention of the rules, William Webb Ellis caught the ball and ran with it.

The story seems fanciful to me and many others, but if true, he was cheating and should have been sent to bed without any supper. A statue outside the school shows the boy running with a ball and a photograph of it is included in this book. Whatever Webb Ellis's contribution, the game was developed at Rugby School. It is said to be a game for ruffians played by gentlemen, and I am sure that this is at least half true.

Rugby has a large railway station and at one time lines diverged from it in seven different directions. I would like you to imagine that you were standing on one of the platforms at 9.15 p.m. on 20 August 1895. Many people would have been with you and quite a few of them would have been holding pocket watches. All would have been looking to the south and straining to be the first to see a puff of smoke. At 9.18 and 45 seconds, amid much cheering, you would have seen the 8.00 p.m. Euston to Aberdeen overnight express rush through the station. It would have covered the 82.6 miles from Euston at an average speed of 65.2 mph. The rest of this section tells the story of the railway races of the late nineteenth century.

Euston was the original gateway to the north, and it tried hard to stop the East Coast line being built. It failed, but the attempt caused ill feeling that lasted for decades. The Great Northern Railway opened King's Cross in 1852. Both the London & North Western Railway (hereafter called the West Coast) and the Great Northern Railway (hereafter called the East Coast) developed alliances with other railway companies and ran trains through to Scotland. The East Coast was generally the quicker and was often regarded as the premier route. In 1852 Euston to Edinburgh took 12 hours, but Kings Cross to Edinburgh took 11 hours.

In 1888 this state of affairs was challenged by the West Coast, which had the harder route to Edinburgh. In June it cut the time of its fastest train to the city by an hour in order to match the East Coast time of 9 hours. The East Coast promptly went to 8 hours 30 minutes and over a few weeks they both progressively scheduled improvements. The competition was all in the timetables rather than out and out racing, and it culminated in the East Coast announcing 7 hours 45 minutes from 14 August. In anticipation of this the West Coast, which was on 8 hours, cleared the lines and ran its train into Edinburgh in 7 hours 38 minutes on 13 August.

At this point they called a halt, with the schedule left at 8 hours for the West Coast and 7 hours 45 minutes for the East Coast. The West Coast could not resist a final run of 7 hours 27 minutes on 3 August, but then the rather uneasy truce lasted for seven years. During all this, passenger comfort had not been neglected and both lines had maintained a stop for lunch. The times allowed were cut, but it was still 20 minutes at both York and Preston.

The Forth Bridge was opened in 1890. This enabled the East Coast to cut its scheduled time for the King's Cross to Aberdeen run. Both lines had 8.00 p.m. trains from London to Aberdeen. The 1888 agreement did not apply to running north of Edinburgh, and scheduled times were progressively reduced. In early July 1895 it was 11 hours 40 minutes for the West Coast and 11 hours 20 minutes for the East Coast.

Hostilities were declared without warning by the West Coast on 15 July. From that very night the journey time would be cut to 11.00 hours and their 8.00 p.m. train was scheduled to arrive at 7.00 a.m. The promise was kept and on the morning of 16 July their train ran in at 6.47 a.m. The following morning it arrived even earlier at 6.21 a.m., a full 39 minutes ahead of the accelerated timetable. The East Coast then announced a 35-minute acceleration that would have its train arriving at at 6.45 a.m. The race was on.

Three companies operated the 523.2-mile East Coast route – the Great Northern from Kings Cross to York, the North Eastern from York to Edinburgh and the North British from Edinburgh to Aberdeen. Two companies operated the 539.7-mile West Coast route – the LNWR from Euston to Carlisle and the Caledonian from Carlisle to Aberdeen. So the West Coast trains travelled 16.5 miles further, and they had slightly harder gradients. In fact the race was to Kinnaber Junction, which was controlled by a West Coast signalman. The 38 miles from Kinnaber to Aberdeen were single-track.

Racing took place during the next five weeks. Times came progressively down, but until the frantic last race of all the West Coast always won, though by diminishing margins. The trains, but especially the East Coast trains, were run with at least one eye on the timetables, which were progressively accelerated.

Public enthusiasm built up, but not everyone thought that racing was a good idea. It had a disruptive effect on other trains and some people wondered why anyone would want to arrive in Aberdeen before breakfast. One wag said that going to Aberdeen at all was a penance, but that getting there in the dark made it worse. This was of course a terrible slur on the magnificent granite city. Above all there were concerns about safety. No accidents were recorded, but worries were inevitable. On the night of 21 August there was a 5 mph speed restriction through Berwick station, but the onlookers scattered in fright as the train rushed through at speed.

The statue of William Webb Ellis outside Rugby School.

For the last two nights the trains were shortened, the timetables were abandoned and it was unrestricted, out-and-out racing. On the night of 20 August the East Coast was ahead nearly all the way, but the other train caught up with just a few miles to go. The trains raced almost side by side, but the West Coast got to the junction first. The winning margin at Kinnaber was less than a minute and the West Coast arrived in Aberdeen at 4.58 a.m.

The final night's racing was even faster and even closer. The trains reached Kinnaber at virtually the same moment, and according to one account it was at exactly the same moment. The two bells calling for access to the single track rang almost simultaneously; perhaps exactly simultaneously. If it really was a dead heat, the signalman (who was employed by the West Coast) must have had a very sporting nature. The West Coast train was stopped and the other train went through for the East Coast's only victory. It arrived at 4.40 a.m. and the West Coast at 4.54 a.m. Both times were records for the respective competitors.

At this point the East Coast followed the sound military tactic of 'declare a victory and bring the boys home'. They called off the races and reverted to their enhanced timetable. The West Coast was not willing to let matters rest without reclaiming the honours. It mounted a final, unopposed assault on the evening of 22 August. Its train left Euston in the midst of a mighty thunderstorm and broke the record all the way. It was non-stop to Crewe and the engine change at Carlisle was accomplished in 2½ minutes. The West Coast train pulled into Aberdeen Station at 4.32 a.m. on the morning of 23 August, beating the previous night's record by 8 minutes. It had travelled 539.7 miles in 8 hours 32 minutes, and at an average speed of 63.3 mph.

Your journey through Rugby will hopefully and probably be quicker and more comfortable, but not nearly so exciting.

Brandon Wood

Brandon Wood is about 8 miles beyond Rugby and about 3 miles before Coventry, and it is about a mile beyond a marvellous Robert Stephenson Grade II listed viaduct. This was built in 1838, has thirteen arches and is less than 40 feet high. The viaduct crosses a road and the River Avon. The Royal Oak, a large public house, is on the right of it and is a prominent landmark. The line bisects the pretty villages of Wolston on the left and Brandon on the right, though Brandon Stadium at the edge of the village can hardly claim to be pretty. A person less charitable than me might call it ugly. A considerable length of the wood can be seen from a point about half a mile after the viaduct and it is necessary to look slightly forward. After a relatively short distance the train goes into a cutting.

The wood covers 178 acres and is mentioned in the Domesday Book. Since 1981 it has been maintained and improved by voluntary workers from Friends of Brandon Wood, and it is now reverting to natural, broad-leaved woodland.

In 1979, Brandon Wood was put up for sale by the Forestry Commission and possible uses for the land included housing, and sand and gravel extraction. Four people met and

resolved to save it from this fate. With others they formed an organisation that moved from protest group to conservation society, and then to participant in the management of the wood. In 1996 they started raising money and in 2000 the woodland passed into the ownership of Friends of Brandon Wood. How splendid! I cannot resist an editorial comment – as Sir Bruce Forsyth might have said, 'didn't they do well?'

Friends of Brandon Wood train in woodland skills to enhance the bio-diversity of the wood. A long-term aim is to restore the wood to mainly broadleaf trees by thinning the conifers that were planted densely by the Forestry Commission in the 1960s. This will take many decades as the work needs to be done sensitively, and it seems safe to assume that readers of this book will not see the end of this, but perhaps we should not be too sure. It is confidently asserted that the first human who will live to 150 has already been born. The Friends of Brandon Wood train in woodland skills and aim to enhance the biodiversity of the wood. Among other things this involves the encouragement of wild flowers, birds and butterflies. More than 330 different types of plant have been recorded and this number includes more than fifty species of tree. So have five species of bat, grass snakes, slow-worms and numerous species of butterfly. There are several ponds and they contain hundreds of frogs, as well as both great crested and smooth newts.

Brandon Wood near Coventry.

The website of Friends of Brandon Wood is www.brandonwood.org.uk. The organisation is a registered charity and you will not be surprised to learn that they welcome both contributions and volunteers.

Coventry Cathedral

The spire of medieval Coventry Cathedral is on the right and can be seen for a short distance immediately after Coventry station. You will see three spires – one in the foreground and two further back. The cathedral spire is one of the ones further back, and is on the right. The one on the left is the impressive Holy Trinity church.

Over a period of nearly a thousand years, Coventry has had three cathedrals, the last two named for St Michael. The first was founded in 1043 as a Benedictine community by Leofric, Earl of Mercia, and his wife Godiva. The story of her legendary (and probably mythical) naked ride through the streets of Coventry is very well known. The medieval cathedral whose spire you can see was mainly constructed in the late fourteenth and early fifteenth centuries. After more than half a millennium it was destroyed by German bombing raids on the night of 14 November 1940.

Coventry was a prime target for the Luftwaffe because of its factories and contribution to the war effort. It had already suffered several air raids, but the night of 14 November 1940 is remembered as one of the horrors of the Second World War. Of the 515 bombers that targeted the city, only one was shot down. The raids lasted ten hours and did achieve their aim of destroying or damaging numerous factories. They did not break the will of the workers though, who set about rebuilding their lives and rebuilding production.

A bomber, especially in 1940, finds it difficult to distinguish a factory from a row of houses, or indeed a cathedral. At least 568 people were killed and 863 were seriously injured. Over 4,000 houses were destroyed and two thirds of the city's buildings were damaged. Only the cathedral's tower, spire, outer wall and bronze effigy of the first bishop survived. The words 'Father Forgive' were later inscribed on the wall behind the altar of the ruined building. The surviving tower is still a functioning bell tower.

A quote from the cathedral's website provides an apposite link from a consideration of the old building to a consideration of the new one:

> To walk from the ruins of the old Cathedral into the splendour of the new is to walk from Good Friday to Easter, from the ravages of human self-destruction to the glorious hope of resurrection. Your heart is lifted, your spirit is renewed and you feel that there is hope for the world. Thanks to God's mercy reconciliation is possible.

The decision to rebuild the cathedral was taken on the morning after the bombing, and furthermore it was immediately decided that it would be done in a spirit of forgiveness and reconciliation.

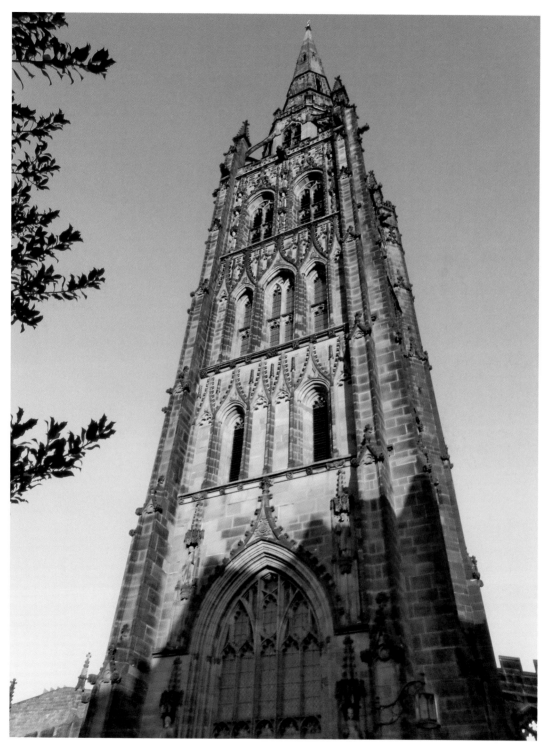

Spire of the bombed Coventry Cathedral.

Had I been a citizen of Coventry that morning, my thoughts I'm sure would not have been of forgiveness and reconciliation. They were certainly not the thoughts of my parents on the morning of 22 March 1941, after their home and a significant part of Plymouth had been destroyed in a similar raid. However, Coventry Cathedral developed as a Centre for Reconciliation. A major part of the ministry was the establishment of the Community of the Cross of Nails. This is an international network of over 170 partners in 35 countries, committed to a shared ministry of reconciliation.

In 1950 a competition was launched to find the most suitable design for the new cathedral, and the winning submission out of the 219 received was from Basil Spence, later to be Sir Basil Spence. The foundation stone was laid by the Queen on 23 March 1952 and the building was dedicated in her presence on 25 May 1962. It was immediately next to the ruins, so that the two cathedrals were effectively just one. The modern style of the new cathedral was not universally acclaimed, but the admirers greatly outnumbered the detractors. It is now more than half a century old and a much-loved building.

The new Coventry Cathedral has many impressive features. They include a compelling 72-foot-high tapestry designed by Graham Sutherland and, perhaps most striking and memorable, an 81-foot-high baptistry window by John Piper. This contains 195 lights of stained glass in bright primary colours. Each individual window contains an abstract design and the overall effect is breathtaking. Outside are two imposing statues by Sir Jacob Epstein, of St Michael and the Devil. The choice of sculptor was controversial because Epstein was a Jew. This objection was put to Sir Basil Spence, who replied 'and so was Jesus Christ'.

If you ask a friend who or what they associate with the city of Coventry, the most likely response will be Lady Godiva and Coventry Cathedral. I like to think that the former would have approved of the latter.

Hampton-in-Arden

Hampton-in-Arden is about 9 miles beyond Coventry and shortly before Birmingham International station. It has its own station that is in a cutting. The cutting starts a quarter of a mile before the station, and at this point, on the left side, is a handsome office building called Hampton Court. It is topped by a clock and a weather vane.

Hampton-in-Arden is mentioned in the Domesday Book and among the various farms and assets are listed four slaves. Thankfully, in some respects at least, things have changed for the better since then. As its name suggests, the village is situated in the Forest of Arden. At one time the forest covered a very large area in central England, stretching from Stratford-upon-Avon in the south to Tamworth in the north.

The village has a lot of fine houses and many of its residents commute to Coventry, Birmingham and Solihull. The central part of the village is a designated conservation area and parts of the parish church of St Mary and St Bartholomew date back to the middle of the twelfth century.

Who wrote Shakespeare's plays? Most people think that Shakespeare did and I am one of their number. However, there are doubters and Christopher Marlowe and the Earl of Oxford are two of their favoured candidates. The case for the Earl of Oxford was espoused in a book by a Gateshead schoolteacher with the unlikely name of J. Thomas Looney. Part of the doubters' case is that Shakespeare lived more than 400 years ago, was not very well educated and probably never travelled further than London. How could he have acquired a comprehensive knowledge of the Royal Court, Scotland, Italy and numerous historical personalities and events? *As You Like It* is a counter to all this. Shakespeare (if it was indeed he) set the play 'in his own backyard', in the Forest of Arden. You might like to think of this as you travel through the village.

Hampton Manor is of great interest and worth a visit. It is now a fine hotel and I can vouch for the quality and surroundings of a snack lunch. The hotel is set in 45 acres of mature woodland and approached by a sweeping drive. The building was for many years a residential home for adults with learning difficulties, and only became a hotel in 2007.

Hampton Manor Hotel in Hampton-in-Arden.

The manor was built by Sir Frederick Peel after he inherited the estate in 1850 from his father, Sir Robert Peel. Sir Frederick came from a very successful family. His grandfather was an MP and a very wealthy Lancashire mill owner. His father founded the Metropolitan Police and was twice Prime Minister. One brother was a naval officer awarded the Victoria Cross and another was Speaker of the House of Commons. Sir Frederick had a long and distinguished political career and was several times a member of the cabinet and shadow cabinet. In 1873 he became a member of the Railway & Canal Commission and served until his death in 1906. It is widely but mistakenly believed that he used his influence to secure a railway station for Hampton-in-Arden. Peels Restaurant in the hotel is named in his honour.

Birmingham International

Birmingham International station is next to the M42 motorway and was opened as recently as 1976. There is plenty to see if you look around.

Birmingham Airport was previously called Birmingham International Airport, which is why the rail station is called Birmingham International. It is on the left side of the line, level with the station and forward of it. The Birmingham International Interchange is a people mover and takes passengers directly from the station to the airport and vice versa. Children love it and I am a child at heart, so I loved it too.

The airport was opened by the Duchess of Kent on 8 July 1939, which was just fifty-seven days before Mr Chamberlain said, 'I have to tell you now that no such undertaking has been received, and that consequently this country is at war with Germany.' The airport was requisitioned by the Air Ministry and used by the RAF and Royal Navy as a flying school. It was returned to civilian use in 1946 and both its facilities and the number of passenger movements progressively expanded over the succeeding years.

In 1987 ownership passed to Birmingham International Airport PLC, a company owned by seven West Midlands District Councils. In 1993, 51 per cent of the local authority shares were sold to a private company. As with most airports, expansion continued and continues. A second terminal opened in 1991 and the runway is currently being lengthened. Birmingham Airport is the seventh busiest in the UK and in 2012 it handled 8.9 million passengers.

I generally find airports stressful and do not like them, but my visit when preparing this book was surprisingly peaceful, even enjoyable. I was not there as a passenger, but they seemed to be doing a lot of things right.

The National Exhibition Centre is immediately next to the station, close to it and on the left side. It was opened by the Queen in 1976, and it now has twenty-one interconnected halls set in 628 acres. It is the largest exhibition centre in the UK and the seventh largest in Europe. The centre offers extensive catering and banqueting facilities, and hosts around 160 trade and consumer exhibitions each year. Since 1991 these have included Crufts, the world's largest dog show, which attracts about 160,000

Terminal Building at Birmingham Airport.

visitors over a four-day period. The Motor Show was held at the National Exhibition Centre from 1978 to 2004.

The LG Arena, with the National Exhibition Centre, is part of the NEC Group. It was originally the NEC Arena, but was renamed in 2008 following a sponsorship deal with the electronics group LG. This agreement will soon have run its term and the arena may then be renamed.

A significant overhaul of the arena was completed in 2009 and this included 1,000 additional seats, bringing the capacity up to 16,000. The venue hosts major concerts and sporting events, including the Horse of the Year Show. A list of the musical stars who have appeared there is long and glittering. The fact that I do not recognise most of the names says more about my interests than the fame of the artists. I did though, among others, recognise Rihanna (2013), Cheryl Cole (2012), Britney Spears (2011), Cher (2004), Tina Turner (on eighteen occasions), David Bowie (various dates), Queen (various dates), The Spice Girls (1998), and Pet Shop Boys (1991).

St Andrew's Stadium:
Home of Birmingham City Football Club

St Andrew's Stadium is on the left side of the train and about a quarter of a mile from the line. It is immediately before the Curzon Street site and about three quarters of a mile before New Street Station.

The stadium is in the Bordesley district of Birmingham and has been the home of the football club since 1906. The early capacity was estimated to be 75,000, with 4,000 sitting under cover, 22,000 standing under cover and 49,000 standing in the open. The capacity was set at 68,000 in 1938 and just under this number attended a fifth-round FA Cup tie against Everton in February 1939. Unlike now, the FA Cup was taken seriously in those days.

St Andrews had a bad time in the Second World War. On the outbreak of hostilities it was closed on the orders of the chief constable, the only ground in the country to be shut in this way, and it was only reopened after the matter was raised in Parliament. Subsequently the Railway End and the Kop were badly damaged by bombing, and then later, in a bizarre mishap, the Main Stand burned down. When damping down a brazier a fireman mistook a bucket of petrol for a bucket of water.

The stadium was rebuilt, but by the late 1980s was in a very bad way. A six-year redevelopment started in 1993 and it is now a pleasant all-seater stadium. The capacity is 30,016.

St Andrew's has been used for boxing as well as football. In 1949 Dick Turpin beat Albert Finch on points to retain his British and Empire middleweight title. Turpin's brothers, Jack and future world champion Randolph, fought on the undercard. In 1965, after a postponement caused by rain, Henry Cooper beat local hero Johnny Prescott to retain his British and Commonwealth titles.

St Andrew's Stadium in Birmingham.

On the playing side, Birmingham City's record could be described as mixed. The best periods were the mid-1950s and early 1960s. The top season was 1955/56, when the club finished sixth in the first division and was the losing finalist in the FA Cup. They were finalists in the Inter-city Fairs Cup in both 1961 and 1962, and they beat local rivals Aston Villa to win the League Cup in 1963. Birmingham City was relegated in 1986 and it was then out of the top tier for sixteen seasons, two of them being spent in the third tier. Birmingham were ninth in the Premier League in 2009/10, but were relegated in 2010/11. However, in that season they did win the League Cup (then known as the Carling Cup) for a second time. At the time of writing, Birmingham City are in the Championship and occupy a mid-table position.

Birmingham City's most famous player was the goalkeeper Gil Merrick. He played 551 times for Birmingham and 23 times for England. His international games, which

were all played while Birmingham was in the second division, included the 6-3 and 7-1 thrashings by Hungary. This led to him being dubbed 'Mister 13' because of the number of goals that he conceded in these two matches. This was unfair because Ferenc Puskas and the Magical Magyars were unstoppable and the whole team was outplayed. For ten years, and while playing for England, he worked four days a week as a schoolmaster. Can you imagine a current England footballer doing that? In 2009 Birmingham renamed the Railway Stand the Gil Merrick Stand in his honour.

Curzon Street, Birmingham: The Site of Past and Future Stations

The Curzon Street site is a very large vacant area, on the right side of the train, almost immediately after St Andrew's Stadium and half a mile before New Street station. The surviving entrance building can be seen at the edge of the site, looking forward.

My first reaction was surprise at the very large size of the Curzon Street site. My second was to think that it must be worth a massive amount of money. It certainly has some history. A plaque on the entrance building reads as follows: 'Curzon Street Station. This plaque commemorates the 150th anniversary of the arrival of the first London to Birmingham train on Monday 17th September 1838.'

Soon after the station opened for the London & Birmingham Railway, the Grand Junction Railway started using it too. It ran trains from Birmingham to Manchester and Liverpool, and the two companies had parallel platforms. There were no through trains, but with a change it was possible to travel from London to Manchester or Liverpool. The two companies plus the Manchester & Birmingham Railway merged in 1846 to form the London & North Western Railway (LNWR). This was for some time the biggest joint stock company in Britain.

After the merger work started on New Street station, which was more centrally located, in 1852 the name of the original station was changed from Birmingham to Birmingham, Curzon Street. New Street station was completed in 1854 and this substantially replaced Curzon Street. However, the old station was still used for excursions and for local services to Sutton Coldfield. It was closed for passenger traffic in 1893.

Curzon Street was used as a goods station until 1966, when the platforms and station sheds were demolished. The scale of the operation can be gauged from the fact that in 1914 2,000 workers were employed there and 600 horses were stabled on the site. There must have been an awful lot of manure.

There are a lot of facts and dates so let us have a brief respite with an American manure story. President Lincoln's wife, Mary Todd Lincoln, was wildly extravagant and frequently embarrassed about money. On one occasion she organised the sale of manure from the White House stables and pocketed the money. The scandal was hushed up.

Entrance building at Curzon Street in Birmingham.

Now back to Curzon Street. The site was used as a Parcelforce depot until 2006.

Most of this section of the book invites you to look at a big open space and to imagine what was once there and what will be there. The exception is the Grade I listed entrance building, which can clearly be seen at the front edge of the cleared area. This was built for the London & Birmingham Railway and it is the world's oldest surviving piece of railway architecture. It was designed by Philip Hardwick, who also designed much of Euston station in London.

The building might be considered surprisingly small, though it should be remembered that the station originally had just an up platform and a down platform for London trains. The Grand Junction Railway had its own building and its own platforms. There are three floors and tall pillars at the front. It was to be flanked by two arches but these were never built. The interior contained a booking hall, staircase, refreshment room and offices. A hotel extension was added in 1840, but the hotel was later closed and the building used as offices. It was afterwards demolished.

The entrance building is now unused except for occasional art exhibitions. Happily it survived the intention of British Rail to have it knocked down. Birmingham City Council intervened and purchased it.

It now seems certain that the line for the new High Speed Train (HS2) from London to Birmingham will be built, and that it will later be extended from Birmingham to Manchester and Leeds. However, governments can change their minds or renounce decisions of their predecessors. It has happened before. Assuming that the HS2 line is built, Curzon Street will be restored to its Victorian glory. Indeed, it will greatly exceed it. This is because it will be the site of the Birmingham station for the new line.

The intention is that the new station will have six platforms, each 1,362 feet long. Anyone who has travelled from London on the Eurostar will know that the trains are very long. There may be a swift passenger link from Curzon Street to New Street station.

The new station will regenerate the surrounding area known as Eastside. There will be offices, hotels, and our national recreation of shopping will not be neglected. There will probably be a new museum quarter, with museums on or close to the new Curzon Square. So what about the world's oldest surviving piece of railway architecture? There will be a national uprising if this suffers the same fate as the Euston Arch in the 1960s. Fortunately it seems that this is not likely and it may well become a museum of photography.

New Street Station, Birmingham

New Street station is just a short distance beyond St Andrew's Stadium and Curzon Street.

Glasgow was once termed the second city of the Empire, but the accolade rightly belonged to Birmingham, and if for Empire you substitute the word Commonwealth, it still does. So you can justly feel important as your train pulls in. New Street station

is right in the middle of the city and your 115-mile journey from Euston station in London is over, though some trains continue on to Wolverhampton.

The journey started at a station not highly regarded by many, Euston in London, and it ends at another with the same reputation. I am inclined to be tolerant, but it is by no means a pretty sight. A recent survey gave it a 52 per cent customer satisfaction rating, the joint lowest of any major Network Rail station. The dubious honour was shared by Liverpool Lime Street and Croydon East.

I have used the station many times and with just one exception have had no cause to complain. The exception, some years ago, was an evening of chaos when the announcements bore little relation to what was actually happening. Promised trains failed to arrive and trains that had been announced as cancelled pulled into different platforms. Frustrated passengers rushed about trying to find out what was happening. I pointed this out to a member of staff, but she said that the announcements were controlled from a distant location and were not influenced by anyone at the station. It is perhaps unkind to mention it, because it has not happened since.

New Street is Britain's busiest interchange station outside of London, and it always has been busy. In 1900 it handled forty trains an hour and fifty-three trains an hour at peak times. That meant a great deal of smoke and soot from the steam trains. There are now around 1,350 trains and over 120,000 passengers a day.

New Street replaced Curzon Street, and it was completed in 1854. The original building had the largest single-span iron and glass roof in the world. It was 840 feet

New Street station in Birmingham.

long and 212 feet wide, and held the record for twelve years until the completion of St Pancras station in London in 1868. The splendid structure was badly damaged by bombs in the Second World War and it was demolished soon afterwards.

The station was rebuilt in the 1960s, at the time of the modernisation of the West Coast line. It was at much the same time as the rebuilding of Euston station in London, and its critics say that it was done in much the same unsympathetic way. In fact the words ugly and brutal are sometimes used. There are twelve platforms covered with a 7-acre concrete slab, and the concourse and other buildings are on top of it. The Pallasades shopping centre was built above the station, and this and the station are partly integrated with the Bullring shopping centre.

New Street station is bursting at the seams and another rebuilding project is underway. It should be completed in 2015 and is planned to cost £598 million. Passenger capacity will be considerably increased and the station will be lit by natural light for the first time since the 1960s. There will be a new station façade, eight new entrances, forty escalators and fifteen public lifts. Thousands of stainless steel panels, made in Sheffield and covering 23,920 square yards, will be attached to the outside of the station to improve its appearance.

In April 2013 the concourse was closed and three new entrances into the first half of the new station were opened. The plans for the finished station look very attractive, but of course plans always do. I am optimistic.